Empty        Spaces

Also by Jordan Abel

*NISHGA* (2021)
*Injun* (2016)
*Un/inhabited* (2014)
*The Place of Scraps* (2013)

# Empty            Spaces

JORDAN ABEL

Yale UNIVERSITY PRESS    NEW HAVEN & LONDON

First published in Canada in 2023 by McClelland & Stewart and in the United States in 2024 by Yale University Press.

Copyright © 2023 by Jordan Abel.
All rights reserved.

This book may not be reproduced, in whole or in part, including illustrations, in any form (beyond that copying permitted by Sections 107 and 108 of the U.S. Copyright Law and except by reviewers for the public press), without written permission from the publishers.

Yale University Press books may be purchased in quantity for educational, business, or promotional use. For information, please e-mail sales.press@yale.edu (U.S. office) or sales@yaleup.co.uk (U.K. office).

Book design by Terri Nimmo.
Interior art by Jordan Abel.
Typeset in Sabon MT Pro by M&S, Toronto.
Printed in the United States of America.

Library of Congress Control Number: 2023943466
ISBN 978-0-300-27554-4 (hardcover : alk. paper)

A catalogue record for this book is available from the British Library.

This paper meets the requirements of ANSI/NISO Z39.48-1992 (Permanence of Paper).

10 9 8 7 6 5 4 3 2 1

*For Phoenix & Chelsea*

"Decolonization is not a metaphor."
—*Eve Tuck & K. Wayne Yang*

"How can we convert into image and narrative the disasters that are slow moving and long in the making, disasters that are anonymous and that star nobody, disasters that are attritional and of indifferent interest to the sensation-driven technologies of our image-world?"
—*Rob Nixon*

*Backscattering*

# I

A deep, narrow chasm. Black rocks. The river lies still on those black rocks. A mile above, there is a tumbling; there is a moment. At this very moment, there is a tumbling in the air a mile above us that runs straight through the open heavens and into some other place. A deep hollow. No shape. No consistency. No breaking some hundred feet in the air. Some places are softer than others. Some hundred feet up in the air. Some right angles enter into narrow passageways and some right angles break off a mile in the air above us. These rocks are full of cracks. Water has worked through some deep hollows. Breaking here. Wearing there. Breaking and wearing until the chasm separates into two caverns. Some hundred feet in the air there is no danger. There is scattered driftwood and the scent of roses. There are glimpses of roses and rocks and shrubs in the spring rain. There is a steep, rugged ascent. A path that winds among the black rocks and trees. Somewhere in the air there is the scent of roses. Somewhere out there is the wilderness. A reasonable distance through scenes of greenery and nature and glimpses of mountain ranges that disappear just as suddenly as they appear. Among the rocks and trees, there are mounds of earth and other rocks and other driftwood. Somewhere there is an islet and another islet and a clear sheet of water and bald rocks just beneath the surface. There are forests and straits and islets and rocks and

somewhere in the air is the scent of roses. There are crevices and fissures and rocks. The rocks surround themselves with other rocks. Although there are sometimes mounds of earth in between. On the shore, there are fragments of rocks. In the deeper parts of the river, there is more tumbling. At this very moment, the river pours into a wide fissure where it just becomes more water between rocks. Between the broken rocks and the deep, roaring cavern, there is the scent of roses and driftwood and trees. There is light. There are straight, naked rocks and immovable trees. There are woods and rivers. And the bed of this particular river is ragged with rocks and intersecting ravines that cut silently across the water above. Somewhere in the air is the scent of roses. The woods are full of sounds and rocks and trees. The woods are full. The upper air, where it drifts over the tops of trees, is full of sounds. Just where it breaks over the tops of trees, there are slow, intermingling drifts of sounds and scents that brush over the clearing some hundred feet up in the air. Rocks and logs and mounds of earth and narrow fissures and bottomland and little ponds and pouring rain and a brook that shoots through the narrow fissures, spreading through moment after moment of stretched light. There is a bellowing in the passageways between the rocks. There are moments of admonished madness. There are moments spreading over the acres of bottomland. There are precipices and adjacent lakes and headwaters. There is a fierceness here that floats through the waters. These rivers are full to the brim. These waters stream down to our feet. In six hours, these waters will rush in. And in another six hours, these waters will rush out. Salt grows in this water. The water in the woods and on the lakes and in the higher

parts of the sea. Stretching out horizontally until the current flows
upward like blood at the throat. On these waters, the edges touch
the shores and the dirt paths trace back to the streams. In the short
distance between the water and the black rocks, there is a deep
shadow. The breath of the stream. The glancing waters. The throat
of the river. These woods are full. Gliding above somewhere up in
the impenetrable darkness is the scent of roses. Somewhere there
is the sound of rushing waters ringing through the deep stillness of
the night. The moon rises and the light glances here and there on the
water and down to the riverbed. At times, the light hangs in the air
on the breath of the river. There are dark waters; there is night.
This is the unmingled sweetness of air that sinks into the foaming
waters. These are the vaults of the forest. There is a stillness here
somewhere in the wilderness. There is lightning and then there is
stillness. There are echoes that rush through the forest until they
disappear. A mile above, there is a tumbling. In the foaming waters,
there is the colour of blood gushed from some other place. Some
other throat. Some other, softer place. Some waters carry the dead.
Somewhere up in the air there is the scent of roses. Some flames last
forever. Some waters thicken with limbs and bodies and trembling
voices. Some waters are still. Somewhere in the velocity of the
uproar there is a current of air. An unmingled sweetness that sinks
in to the forest. The narrow path adjacent to the brook is full of
bodies. The blood as natural as water. Glassy mirrors. The sunken
hillsides. The shores. The black rocks between the mounds of
earth. The glittering stars. The open air floating over the forest.
The warm spring wind. In the valley, the stream overflows onto the
banks. Here, the tumbling water washes bones and the waters of

the river flow into the sea. There is a canopy from the woods spreading over the lake, shadowing a dark current with a deep hue. When the sun is setting, these waters become healing waters. But the sun is not setting and the current branches silently into the dark parts of the lake. Somewhere in the forest bark is peeled from a tree. Branches break. For many minutes, there is a struggle and a deep, cool wind. There is a current of air. There is silent motion plunging and glancing and sweeping over the broken branches. The sound from the rushing waters drifts through the air. There are words and yells and cries. As the air flows up from somewhere in the deep, narrow ravine, there is silence again. With the exception of the sounds that come from the rushing water. A clear tide. Up stream. Beneath some low bushes is a silent river. Branches wave in the current. They call this river by a name. For many moments, the branches bend in the eddies and the arm of the silent river turns towards itself. For many moments, the name of the river hangs in the air. Every few yards, bubbles appear on the surface, are filled with light and disappear. At the shore, there is a dead silence and then there are quiet voices. The voices are obscured somewhere below the ragged treetops. The rise of air. The melting pockets of snow. Somewhere under the ragged treetops is the growing sound of voices. Somewhere on the river bark can be seen floating along with the current. The down stream current. The far-down current, sinking again beneath the air. The current that swells and sinks and crashes against the rocks, echoing through the vaults of forest and the sweetness of nature. Still, there is breath. There are voices. In the caverns below, there is air that rises. The voices are just sounds in the woods. The air. The sparks. The flames. The smoke. The rain.

The cool spring breeze along the surface of the river. Thunder rumbles beyond the distant hills. Any signal. Any water. Any alarm far down the current. Still, the air sinks into the caverns below and the voices sink too. What hazardous undertakings. What trusted intent. Which current glides towards fortune and which current turns treacherous? The river plunges into the ravine and the mist rises like smoke. For a few moments, the mist is the smoke before it falls back into the river. For a few moments, there is a plume of water crested by the light that cuts through the forest. Somewhere in the trees there are leaves decaying on a path. Behind the curvature of the path, there is a dark, wooded outline and a soft, silvery wind. The heavens and the drifting vapours and the broken treetops and the sullen sounds and the evening atmosphere and the blazing fire and the deep laughter and the broken rocks and the roaring cavern and the tumbling water and the impenetrable darkness and the water glimmering in the moonlight and the hills and the gloom and the moving surfaces and the quiet uneasiness and the wooded outlines and the soft, silvery wind. There is a darkness here that can only be heard. Another voice. Another river. Another mouth. Another body. But which mouth? Which river? Which body? All the knots of pine can be counted. Over there—beyond the hills and skies—spirits rustle the leaves of other forests and the dead listen. When the blood is hot. When black smoke drifts through the camp like a fog. When the vapours are inhaled. When the clouds settle onto the trees. When the dark forest erupts into flames. When there are broken, naked voices and intense heat. Breath and silence and breath again. At the furthest edges of the forest, there is a cavern. A narrow, deep cavern in the rock. North and south spread

over both sides of the lake. In the east, there are as many trees as there are leaves. On the broad side of the trail, the air tastes sweeter and the holy lake occasionally reflects the light of the north star at midnight. Air and bodies and light in the fields. Numberless breaths and thoughts and voices. Stars will shine at night, lighting up the bodies with antlers and hooves. Evergreens will grow. North and south will spread through glimpses of the western sky as seen through the branches of trees and the west will wait. Above the pines, the sky is bright and delicate. Where are the deep shadows? What forms out of the damp morning air? What bitterness? What glory? What country? The rippling stream bends towards every vista. The sun sets in a flood. Coolness spreads through the beach. The woods and the broken masses of rock and the distant western hills and the spectacle of darkness and the pure exhalations of spring and the western shore and the north island and the mountains and silent moments and the shaggy outlines of the tall pines and the spring rain and nearly everything in between. From the woods. From the darkness. From the broken masses of rock. From the distant western hills. From the south. From the western shores that are barely visible in the heat of the afternoon comes a silence that burns like fire. From the northern end. From mountain to mountain. From the western bank of the lake. From eye. From body. From witness. From the fire that sees itself. From the dizzying heights. From the narrow sheets. From truth. From weakness. From speaking. From flame. From the air pouring across the waste waters. From light. From margin. From earth. From broken summits and broken sky. From the tumbling in the air a mile above us. Below the high and broken summits are countless islands and clear sheets of water

running from shore to shore. Dirt trails winding through the trees. The low strands disappearing into the water and reappearing in parallel. After all the hills and the lakes. After all the waterfalls and mists and riverbeds. The morning approaches today. And the morning approaches again tomorrow. From this spot, the water almost seems to linger in the soft heat from the afternoon sun. Beyond the miles of water. Beyond the shores of the lakes. Beyond the danger. Beyond the western waters. Beyond the horizon there are miles and miles of lakes that intersect and overlap, sharing vessels that glide along the currents. The chasms. The black waters. The shores. Somewhere along the horizon the earth disappears. For a few moments, there is no other lake. There are no mountains. There are no waters other than these waters. There are clouds but only at a great distance. The headlands are dotted with countless islands. The islands surround themselves with other islands. Sometimes the elevation plunges. Sometimes the waters rise. Sometimes the north is no great distance. Sometimes the clouds spill out across the sky. Sometimes there is the scent of roses. Sometimes there is a crackling in the sky a mile in the air above us. Sometimes fires die out. Somewhere deep in the woods there is a dark lake at the bottom of a mountain. There are slow waters here. There are echoes and rocks and fissures and bodies and mounds of earth and shrubs. The air here is full of light. Branches sway in the spring air. The air floating and rising and warming at the base of this mountain. In this air, there is the taste of copper. Just where the air floats over the lake, there is scattered light from the brush above. If the waters here are forever, the bodies are for now. Here, the lake is silent and still. Somewhere out there other lakes are broken. Somewhere

waters rush through the woods, pulling down trees that stand too close to the shore. Branches break in those currents. The currents that disappear into the brush and resurface somewhere between the rocks and trees and light. That reappear like glass when the moon is visible. In the heat of the afternoon, there is a bellowing from the rushing wind that rises up through the trees and shrubs and broken branches. Beyond these trees there are bodies with fingers and fur and hooves and mouths. Beyond these woods there are countless clouds spilling out into the sky. Beyond these bodies there are soft voices and light. Somewhere in the forest branches break. The air sinks. The footsteps in the afternoon are covered over by sound from the wind. The breath from the bodies hangs in the air even though it is not visible in this heat. What bitterness hangs in the air? What trust forms from breath? The forests and rocks and immovable mountains that are almost visible from hundreds of miles away. There is scattered conversation. There is silence. There is light shining down on the bodies and the trees. There are echoes that cut through the wind. If the west hangs in the air, then the water must reflect the light from the moon at midnight. If the west is here at all, it is caught up somewhere in the intersecting voices that cut softly through the silence. If the west is to be made, then bodies must float down these rivers. After nightfall, the stars will light up a pathway that winds through the forest and past the lake and between the mountains. But night has not come yet and the pathway remains dark. For a few moments, all breath becomes lost in the smoke. Flames can be seen through the branches. Through the numberless branches and the broken tree limbs and the black rocks and the mounds of earth and the quiet lake. Sometimes when

the sun sets the waters from the lake will look like wildfire. Somewhere out there away from the shore there is a clear sheet of water and bald rocks just beneath the surface. Somewhere out there above the water there is a tumbling in the air a mile above us. Sometimes these waters are full to the brim. Sometimes salt grows in these waters. The water in the lakes and the rivers and the streams and the waterfalls and the brooks that feed into the rivers. Sometimes after all this fire there is the taste of copper in the air. Sometimes there is the smell of roses. On the shore, there is only danger. On the shore, there are clouds of breath. There are bodies that burn other bodies. At the furthest edges of the lake, there is another shore. Another quiet shore where there are as many leaves as there are trees. Here, there is light and stillness and glimpses of grey smoke billowing over the tops of trees in the distance. Another islet. Another mouth. Another voice. There are clouds above the smoke that seem to drift into each other. There are fragments of driftwood along the shore. There are dark mounds of earth and wet, black rocks and broken branches and intersecting lines of sight that cut across each other until there is a moment when those lines converge. For all the broken rocks and immovable trees and deep, narrow ravines, there are hundreds of leaves falling to the ground. For all the leaves that drop to the earth, there is an equal number of clouds that break apart and then come back together again. Beneath the broken clouds is a steep, rugged ascent and a trail of bodies spilling out of the forest and into the lake. There are no sounds anymore except for the crackling of the fire in the woods. There are no shores other than these shores. There are no bodies other than these bodies. In earlier seasons, snow would cover this shore by the

woods overlooking the deep stillness of the lake. But today, there is only spring blooming at the edge of the forest. Today, there is blood gushing from soft, delicate bodies. Blood that floats through the water until it disappears. The bodies, as seen from the bottom of the lake, look almost like a constellation of stars. Here, the soft, silvery winds push the water and bodies through the lake towards the dark, deep places. There is a blackness at the bottom of the lake that seems to absorb all light. For a moment, the light from the bright, delicate afternoon reaches out to this dark place. For a moment, light touches a place it has never touched before. For a moment, the bodies in the lake are lit up again and can be seen very briefly from the shore. Beyond the curvature of the shore there is the dark, wooded outline of the forest. There is rain now in the grey sky and the fire seems to have died out. There are only bright embers. Glowing orange and red chunks of trees that hiss momentarily in the downpour and slowly turn black and ashen. If there is space here for voices, then they are softer than before. If there is space for breaking, it is here and now in the rain overlooking the dark lake. If there is space between the trees and the black rocks and the shrubs and the driftwood, it is filled with mounds of black earth and silence. Somewhere above there is a tumbling in the air a mile above us. Somewhere above there is a soft, silvery wind that disappears into the trees. Some stars are visible now. Some stars can be seen above the lake and through the broken canopy of smouldering trees. Some light from some other, softer place. From somewhere under the deep stillness of the lake there is a current that rises through the waters. A current that cuts through the cool water and ripples the glassy surface. There is a humidity here that lingers just

above the surface. The glittering stars above reflect in these ripples. There is a nakedness out here in this water. The water that has found its way here after winding its way among countless islands, that turned to vapour in the blistering heat of the summer. Water that hung in the air before it poured down on the mountains. There is a mist that drifts through the trees. At this elevation, the shining yellow stars are just a little closer. At this height, about a half mile from the base of the mountain, the sun scorches the ragged tops of trees. There is a gust of wind that follows the curvature of the valleys and glides up to the black clouds one hundred feet up in the air. There is moonlight down on the northern bank. There is light from a thousand glittering stars. On the southern shore, there is the taste of the wilderness in the air. If there are voices. If there are parallels between the tree branches. If the waters rise. If a line is drawn. If there are connections between the precipices. If there are no more hills or banks or caverns or ravines. If the soft curvature of the lake sometimes shines in the light from the sun at dawn. If there are roses. If the bodies float down the stream. If there are bodies with hooves and mouths and fur and fingers. If there are moments that intersect with other moments. If the smoke consumes the forest. If the north bank remains a point in space. If the bodies hang in the trees and above the firepits. If a broken line branches into the west. If the light between leaves is just moonlight. If the outline of the woods at dusk disappears into the night. If there is, in fact, a forest. If there are ripples. If there is fear. If the blood runs like a river. If bark is peeled from a tree. If slow, intermingling drifts of sounds and scents float through the air. If reflections are made from the moonlight. If there is breath and fire and flesh and hunger and land.

If there is a bellowing in the passageways between the broken rocks. If some other, softer place is not softer at all. If blood gushes from every throat. If the darkness never lifts. If there is a tumbling in the air above us. There is a passageway between the broken rocks. Tomorrow, bodies will glide through that passageway. Bodies in the sun. Bodies in the heat of the afternoon. Bodies reflected on the glassy surface of the water. In the evening, after the waters turn dark, flesh will be peeled from the bone. Branches will break. Some flesh is soft. Some flesh hangs from trees. Some flesh carries the scent of roses. Some waters remember these things. Some waters do not. Tomorrow, in the heat of the afternoon, there will be voices. There will be words. There will be ripples spreading outward in the water. There will be a soft, silvery wind. Tomorrow is a half-mile away. Tomorrow is just around the next bend. Tomorrow spreads out horizontally along all the bright, shiny surfaces. Tomorrow, there will be silence. Tomorrow is a circle. Tomorrow is a line that cuts endlessly through the forest. Tomorrow is here again. Tomorrow is here again and again and again. In the river, there is blood. There are broken bones and broken bodies. There is a flat, black rock above the thigh and below the skull. There is a jaw bone resting on the mossy stump of a tree trunk. To remove the thumbs. To puncture the skin. To see the line that connects the femur to the sternum to the antlers. The flesh will fall away; the stars will shine through the clouds at night. There is a clear sheet of water and sinking bodies just beneath the surface. The blood and the spring air and the broken limbs and the silvery clouds and the skulls and the rocks and the deep stillness of the night resting in the palm of a severed hand. When the sun rises. When the light spreads through the trees

and the leaves. When there is a moment. When the bodies can be seen from one hundred feet up in the air. When the river breaks. When the air is full of light. When the names of the bodies are swallowed by the forest. When a soft, silvery wind rushes through the trees. When tomorrow finally arrives.

II

When tomorrow finally arrives. When a soft, silvery wind rushes through the branches. When the bodies are swallowed by the forest. When the summer air is warm and broken. When the bodies seem to disappear from ninety feet up in the air. When there is a moment. When the light spreads through the brush. When the sun directly above the earth is blinding. The air and the broken limbs and the silvery clouds and the blood and the rocks and the skulls and the warmth of the afternoon. There is a clear sheet of water and sunken bodies somewhere below the surface. The stars will shine through the clouds; the flesh will fall away. To see the line that connects the antlers to the sternum to the fingers. To puncture the skin. To remove the claws. There is a jaw bone resting on the mossy stump of a tree trunk. There is a flat, black rock below the thigh and above the skull. There are broken bodies and broken bones. In the river, there is blood. Tomorrow is a line that cuts endlessly through the forest. There will be words. There will be voices. Some waters dry up. Some waters do not. Some bodies carry the scent of roses. In the summer afternoon, the mud will harden and fall from the dried bones. Bodies in the heat of the afternoon. Bodies reflected on the surface of the water. Bodies with antlers and mouths and claws and fingers in the hot sun. Bodies in the passageways. If there are still passageways between the broken rocks. If there is a tumbling in

the air above us. If the darkness never lifts. If blood gushes from every throat. If some other, softer place is not softer at all. If there is a bellowing in the passageways between the broken rocks. If there is land and hunger and breath and fire. If the moon reflects the light from the sun. If slow, intermingling drifts of sounds and scents float through the air. If bark is peeled from a tree. If the blood runs like a river. If there is fear. If there are ripples in the lake water. If there is still a memory of the sun after the woods grow dark. If there are caverns in the rocks that lead us into darkness. If there is old light and a bright mist and glassy rocks. If the woods disappear into the night. If the light between leaves is just moonlight. If a broken line branches into the east. If the bodies hang in the trees. If the south bank remains a point in space. If the smoke consumes the forest. If there are moments that intersect with other moments. If the bodies float down the stream. If there are roses. If the soft curvature of the lake sometimes shines in the light from the sun at dawn. If there are no more hills or banks or caverns or ravines. If there are connections between the precipices. If a line is drawn. If the waters rise. If there are parallels between the tree branches. If there are voices. If the blood sprays into the air. If there are leaves floating in the river. If the water from the river branches silently towards the lake. If the lake stretches for miles and miles. If the rocks just below the surface can't quite be seen. If the thousands of glittering stars above are never quite visible in the light from the afternoon. If the trees that have fallen in the river sink down to the riverbed. If there is the taste of wilderness in the air on the southern shore. If there is a gust of wind that follows the curvature of the valleys and glides up to the black clouds ninety feet up in the air. At this height,

about a half mile from the base of the mountain, the summer sun scorches the ragged tops of trees. At this elevation, the shining stars are just a little closer. There is a mist that drifts through the trees. Water that hung in the air before it pours down on the mountains. The water that finds a way here after winding its way among countless islands, that turned to vapour in the summer heat. There is a nakedness out here in this water. Just above the expanse. Just above the slow, intermingling drifts of darkness. There is a mist here that lingers just above the surface. A current that cuts through the cool water and ripples the lake. From somewhere under the deep stillness of the lake there is a current that rises up from some other, softer place. Some water from some other place. Some reflections. Some blood. Some dirt. Some silence. Some bark. Some limbs. Some antlers. Some branches. Some bodies. Somewhere above there is light from somewhere other than here. Some stars can be seen above the lake and through the broken canopy of smouldering trees. Somewhere above there is a soft, silvery wind that disappears into the trees. Somewhere above there is a tumbling in the air a mile above us. If there is space between the trees and the black rocks and the shrubs and the driftwood, it is filled with mounds of black earth and silence. If there is space for breaking, it is here and now in the rain overlooking the dark lake. If there is space here for voices, then they are softer than before. There are glowing orange and red chunks of trees that hiss momentarily in the downpour and slowly turn black and ashen. There are bright embers. There is rain now in the grey sky and the fire seems to have died out. Beyond the curvature of the shore there is the dark, wooded outline of the forest. For a moment, the bodies in the lake are lit up again and

can be seen very briefly from the shore. For a moment, light touches a place it has never touched before. For a moment, the light from the bright, delicate afternoon and the light from the wildfire reach out to this dark place. Here, the soft, silvery winds push the water and bodies through the lake towards the dark, deep places. The bodies, as seen from the bottom of the lake, look almost like a constellation of stars. Blood floats through the water until it disappears. Blood gushing from soft, delicate bodies. Blood and salt and dark currents. Today, the blood blooms in this water. In earlier seasons, spring flowers would bloom on this shore by the woods overlooking the deep stillness of the lake. There are no bodies other than these bodies. There are no shores other than these shores. There are no sounds anymore except for the crackling of the fire in the woods. Beneath the broken clouds is a steep, rugged ascent and a trail of bodies spilling out of the forest and into the lake. For every cloud that breaks apart, a leaf falls from a tree. For all the broken rocks and immovable trees and deep, narrow ravines. For all the leaves falling to the ground. For all the dark mounds of earth and wet rocks and broken branches and intersecting lines of sight that cut across each other until there is a moment when those lines converge. For all the fragments of driftwood along the shore. For all the clouds above the smoke that seem to drift into each other, another voice can be heard. Another mouth. Another islet. Another clear sheet of water. Here, there is light and stillness and glimpses of grey smoke billowing over the tops of trees in the distance. Another quiet shore where there are as many leaves as there are trees. At the furthest edges of the lake, there is another shore. On the shore, there is breath and there is fire and there is burning flesh

and there are voices. On the shore, there is only danger. Sometimes there is the smell of roses. Sometimes after all this fire there is the taste of copper in the air. The water and the streams and the waterfalls and the brook that feeds into the river. Sometimes salt grows in these waters. Sometimes these waters are full to the brim. Somewhere out there above the water there is a tumbling in the air a mile above us. Somewhere out there away from the shore there is a clear sheet of water and bald rocks just beneath the surface. But here and now, the lake reflects the flames in the forest. Sometimes when the sun sets the waters from the lake will look like wildfire. Through the numberless branches and the broken tree limbs and the black rocks and the mounds of earth and the quiet lake. Flames can be seen through the branches. For a few moments, all breath becomes lost in the smoke. For a few moments, the stars will light up a pathway that winds through the forest and past the lake and between the mountains. If the west is to be made, then bodies must float down these rivers. If the west is here at all, it is caught up somewhere in the intersecting voices that cut softly through the silence. If the summer hangs in the air, then the water must reflect the light from the moon at midnight. If there are echoes that cut through the wind. If there is light shining down on the bodies and the trees. If there is silence. If there is scattered conversation, the forest might break. The rocks might break too. The rocks and logs and immovable mountains that are almost visible from miles away and the driftwood and the trees and the lake. What breaks open out of these sounds? What trust forms from breath? What bitterness hangs in the air? Which bodies hang from trees and which bodies sizzle above the firepits? What sights are not visible in this summer heat? The footsteps in

the afternoon are covered over by the sound from the rushing wind. The air swells. Somewhere in the forest branches break. Beyond these bodies there are soft voices and light and other bodies and breath. Beyond these woods there are countless clouds that spill out into the sky and stretch out horizontally along the horizon. Beyond these trees there is just more forest. In the heat of the afternoon, there is a bellowing from the rushing wind that rises up through the branches and the trees and the shrubs and the broken rocks. For a moment, the moon is visible. The current disappears into the lake and resurfaces somewhere between the rocks and trees and light. Limbs break in the current and on the rocks. Somewhere waters rush through the woods, pulling down trees that stand too close to the shore. Somewhere out there other lakes are broken. Here, the lake is silent and still. If the intermingling drifts of summer heat stretch out to intersect with other winds. If the waters here dry up. If the waters here are forever. If the trees. If the rocks. If the soft, silvery wind. If the bodies. If the voices. If the west. If the air floats over the lake. If there is scattered light from the brush above. If there is the taste of copper in the air. The air floating and rising and warming at the base of this mountain. Branches sway in this air. The air here is full of light. There are echoes and rocks and fissures and bodies and mounds of earth and shrubs and little ponds and mossy stumps and broken bones. There are slow waters here. Somewhere deep in the woods there is a dark lake at the bottom of a mountain. Somewhere along the horizon the earth disappears. The shores. The black waters. The chasms. Beyond the horizon are miles and miles of lakes that intersect and overlap, sharing vessels that glide along the currents. Beyond the eastern waters. Beyond the danger.

Beyond the shores of the lakes. Beyond the miles of unbroken water. From this spot, the water almost seems to linger in the heat from the afternoon sun. The morning approaches again. The morning will approach again tomorrow. After all the waterfalls and mists and riverbeds. After all the hills and the lakes. After all the low strands disappearing into the water and reappearing in parallel. After all the dirt trails winding through the trees. Below the high and broken summits are countless islands and clear sheets of water running from shore to shore. From the tumbling in the air a mile above us. From broken summits and broken sky. From earth. From margin. From light. From the air pouring across the waste waters. From flame. From speaking. From weakness. From truth. From the narrow sheets. From the dizzying heights. From the fire that sees itself. From witness. From body. From eye. From the eastern bank of the lake. From mountain to mountain. From the southern end. From the eastern shores that are barely visible in the heat of the afternoon comes a silence that burns like fire. From the north. From the distant eastern hills. From the broken masses of rock. From the darkness. From the woods. From the spectacle of darkness and the pure exhalations of summer and the western shore and the north island and the mountains and silent moments and the shaggy outlines of the tall pines and nearly everything in between. Here, coolness spreads through the beach. The sun sets in a flood. Where are the deep shadows? What forms out of the damp morning air? What bitterness? What glory? What bodies? The rippling stream bends towards every vista. Above the pines, the sky is bright and pink and delicate. North and south will spread through glimpses of the eastern sky as seen through the branches of trees and the east will

wait. Evergreens will grow. Stars will shine at night. Numberless breaths and thoughts and voices. Air and bodies and light in the fields. On the broad side of the trail, the air tastes sweeter and the holy lake occasionally reflects the light of the north star at midnight. In the west, there are as many leaves as there are trees. North and south spread over both sides of the lake. At the edge of the lake, there is a narrow, deep cavern in the rock. At the deepest depths of the cavern, there is water. Breath and silence and breath again. On the surface, there are naked voices and intense heat. There is a burst of flame. When the clouds settle onto the trees. When the vapours are inhaled. When black smoke drifts through the camp like a fog. When the blood is hot. When the spirits rustle the leaves of other forests and the dead listen intently to that noise. Somewhere out there is a mouth. But which mouth? Which body? Which camp? Which voices? Which forest? Which river? Which summer? Some say that all the knots of pine can be counted. Another notch. Another knot. Another tree. There is a darkness here that can only be heard. The heavens and the drifting vapours and the broken treetops and the sullen sounds and the evening atmosphere and the blazing fire and the deep laughter and the broken rocks and the roaring cavern and the tumbling water and the impenetrable darkness and the water glimmering in the moonlight and the hills and the gloom and the moving surfaces and the quiet uneasiness and the wooded outlines and the soft, silvery wind. Behind the curvature of the path, there is a dark, wooded outline and a soft, silvery wind. Somewhere in the trees there are leaves decaying on a path. For a few moments, there is a plume of water crested by the light that cuts through the forest. For a few moments, the mist is the smoke before

it falls back into the river. Which current glides towards fortune and which current turns treacherous? Which company can be trusted? Which undertakings will be hazardous? The air sinks into the caverns below and the voices sink too. Any alarm far down the current. Any water. Any signal. Any surface. Any thunder rumbling beyond the distant hills. The warm evening breeze sweeps along the surface of the river. The smoke. The flames. The sparks. The air. The voices are just sounds in the air, sweeping through the branches. In the caverns below, there is air that rises up to meet those voices. Still, there is breath. There are bodies. There is a current that swells and sinks and crashes against the rocks, the sound echoing through the vaults of forest and the sweetness of nature. The far-down current, sinking again beneath the air. The downstream current. Somewhere on the river bark can be seen floating along the surface. Somewhere under the ragged treetops is the growing sound of voices. At the shore, there is a dead silence and then there are low voices. Every few yards, bubbles appear on the surface, are filled with light and disappear. For many moments, the name of the river hangs in the air. For many moments, the branches bend in the eddies and the arm of the silent river turns towards itself. They call this river by a name. Beneath some low bushes is a silent river. Clear tide. Up stream. Broken river. Distant sounds that come from the rushing water. As the air flows up from somewhere in the deep, narrow ravine, the rushing water can be heard again. There are deep voices and soft bodies with sharp claws. There is the sound from the rushing water drifting through the air. There is silent motion plunging and glancing and sweeping over the broken branches. There is a current of air. For many minutes, there

is a struggle and a deep, warm wind. Branches break. Somewhere in the forest bodies collapse. Tomorrow, the sun will rise and the current will flow silently into the dark parts of the lake. When the sun rises, these waters become healing waters. When the sun rises, a shadow from the canopy will spread over the lake, creating a dark current with a deep hue. Here, the tumbling water washes bones and the waters of the river flow into the sea. In the valley, the stream overflows onto the banks. The open air floating over the forest. The glittering stars. The black rocks between the mounds of earth. The shores. The sunken hillsides. The glassy mirrors. The blood as natural as water. The narrow path adjacent to the brook is full of bodies. An unmingled sweetness that sinks into the forest. Somewhere in the velocity of the uproar there is a current of air. Some waters are still. Some waters thicken with limbs and bodies and trembling voices. Some flames last forever. Somewhere up in the air there is the scent of roses. Some waters carry the dead to some other, softer place. Somewhere other than here. In the foaming waters, there is the colour of blood. A mile above, there is a tumbling. There are echoes that rush through the forest until they disappear. There is lightning and then there is stillness. There are vaults of forest. This is the unmingled sweetness of air that sinks into the foaming waters. There are bright waters; there is light. At times, the light hangs in the air on the breath of the river. The moon rises and the light glances here and there on the water and down to the riverbed. Somewhere there is the sound of rushing waters ringing through the deep stillness of the night. Gliding above somewhere up in the impenetrable darkness is the scent of roses. These woods are full of bodies and bones and moss and trees. These woods are

full of throats that have not yet been cut. The glancing waters. The breath of the stream. The shores. The mist drifting through trees. In the short distance between the water and the black rocks, there is a deep shadow. On these waters, the edges touch the shores and the dirt paths trace back to the streams. The stream stretches out horizontally until the current flows upward like blood at the throat. The water in the woods and on the lakes and in the higher parts of the sea. Salt grows in this water. In six hours, these waters will rush out. And in another six hours, these waters will rush in. These waters stream down to our feet. These rivers are full to the brim. There is a fierceness here that floats through the waters. There are precipices and adjacent lakes and headwaters. There are moments spreading over the acres of bottomland. There are moments of admonished madness. There is a bellowing in the passageways between the rocks. Rocks and logs and mounds of earth and narrow fissures and bottomland and little ponds and a brook that shoots through the narrow fissures, spreading through moment after moment of stretched light. Just where it breaks over the tops of trees, there are slow, intermingling drifts of sounds and scents that brush over the clearing some ninety feet up in the air. The upper air, where it drifts over the tops of trees, is full of sounds. These woods are full. Here, the riverbed is ragged with rocks and intersecting ravines that cut silently across the water above. Somewhere in the air is the scent of roses. There is light and straight, naked rocks and immovable trees. In the deeper parts of the river, there is more tumbling. On the shore, there are fragments of rocks. Although there are sometimes mounds of earth in between. There is a steep, rugged ascent and a warm summer breeze. There are glimpses of roses and rocks and

shrubs. There is scattered driftwood and the scent of roses. Some ninety feet in the air there is no danger; there are only the broken and the splintered clouds. Water has worked through these rocks. These rocks near the northern summit. Some right angles cut through the forest. Some right angles run parallel to the river. Some ninety feet up in the air there is just light and clouds and cold droplets of water. Some places are softer than others. Some things break apart. Sometimes there is no shape. No logic. No pathway to follow. Sometimes there is just a deep hollow. At this very moment, there is a tumbling in the air a mile above us that runs straight through the open heavens into some other place. Some other, softer place. Sometimes there is a moment. In the woods, a river cuts through the trees. On the shore, there are black rocks and roots and sand. On the shore, there is a deep, narrow chasm that leads down into some other, darker place.

# III

On the shore, there is a deep, narrow chasm that leads down into some other, darker place. On the shore, there are black rocks and roots and mud and tree stumps and broken bones and broken branches. On the shore, a river cuts through the trees. Sometimes there is a moment. Sometimes there are other, softer places. At this very moment, there is lightning and then there is a tumbling in the air a mile above us. At this very moment, white lightning breaks open the sky and runs straight through the open heavens into some other place. In the forest, there is a deep hollow. A gully with a dozen branching pathways to follow. There are no shapes here other than the trees. There is nothing here that breaks apart in the autumn rain. Somewhere deep in the gully there is a soft, dark place. Sometimes eighty feet up in the air there is just light and clouds and cold droplets of water. Sometimes right angles run parallel to the river. Sometimes right angles cut through the forest. Sometimes the water cuts through the rocks near the northern summit. Sometimes the water works through these rocks. Some eighty feet in the air there is no danger; there are only the broken, splintered clouds and the sprawling land. There is scattered driftwood and the scent of roses and mossy rocks and tree stumps and broken branches and wet leaves. There are glimpses of roses and rocks and shrubs. There is a steep, rugged ascent. Somewhere there is a path that winds among

the black rocks and trees. Somewhere out there is the scent of roses. Somewhere out there is another forest, another river, another mouth. Somewhere out there is the taste of danger. Somewhere out there is the sprawling land and the endless horizon. Somewhere out there is the wilderness. Somewhere out there, at some reasonable distance, are scenes of greenery and nature and glimpses of mountain ranges that disappear just as suddenly as they appear. Among the mossy rocks and the broken tree branches, there are mounds of black earth and other rocks and other driftwood and leaves falling to the ground. Somewhere there is an islet and another islet and a clear sheet of water and bald rocks just beneath the surface. There are forests and straits and islets and rocks and somewhere in the air is the scent of roses. In the forest, there are deep, soft places. In the forest, there are hollows and ravines and winding rivers. The rivers connect themselves to other rivers, other lakes, other inlets and streams and waterfalls. In between the rivers, there are sometimes mounds of earth. There are sometimes great expanses of trees and shrubs and brush. In the forest, there are fractured rivers. Rivers that break apart again and again until there is barely a stream running through the thick parts of the forest. In the deeper parts of the river, there is more tumbling. At this very moment, the river pours into a wide fissure where it just becomes more water between rocks. In this river—the river that splits open again and again—there are sunken bodies and bald rocks. Above this river, there is a deep, roaring cavern and there is the scent of roses in the air. There is light and straight, naked rocks and immovable trees and the taste of danger. In this forest, the river will split again and again. In this forest, the river is ragged with rocks and broken branches and

driftwood. In this forest, the river cuts silently through the ravine. In this forest, the scent from the water intersects with the scent of roses floating above somewhere up in the air. This forest is full. The upper air, where it drifts over the tops of the ragged trees, is full of sounds. Just where it breaks over the tops of trees, there are slow, intermingling drifts of sounds and scents that brush over the clearing some eighty feet up in the air. Mossy rocks and logs and falling leaves and rivers that cut through the forest. Mounds of earth and narrow fissures. Bottomland and little ponds and inlets and a brook that shoots through the trees, spreading through the afternoon. There is a bellowing somewhere in the forest above the river. There are moments when the light stretches out across the horizon and fills up the sky. A light that turns the clouds pink and orange and yellow. There is light spreading over the soft expanse of the forest. There are precipices and adjacent lakes and headwaters and summits. There is a fierceness here in the forest. There is a fierceness that drifts along in the rivers. These rivers are full to the brim. These waters stream down to our feet. In six hours, the water from this river will reach the lake at the base of the mountain. In six hours, a few bodies will wash up on the shore of that lake. Bodies with swollen tongues and matted fur and broken antlers and torn skin. The water in the woods and on the lakes and in the higher parts of the sea. The stream stretches out horizontally until the current flows upward like blood at the throat. In these waters, the bodies clump together and the stench floats up into the air. In the short distance between the lake and forest, there is a shore. There is a shore at the base of the mountain where swollen, broken bodies clump together. There are black rocks and deep shadows and

rustling leaves in the forest. There is a cool mist drifting through the trees. There are shores. There is a soft mist floating just above the surface. The breath of the stream. The sharp reflections. The woods and the bodies and the taste of danger. These shores are full of throats that have been cut and limbs that have been severed. These woods are full of bodies and bones and moss and trees and broken branches and rustling leaves and soft, silvery wind. Gliding above somewhere up in the impenetrable darkness is the scent of roses. Somewhere there is the sound of rushing waters. Somewhere in the autumn night there is a deep stillness. At some point, the moonlight touches the water and the riverbed and the broken bodies. At this moment, the light hangs in the air just above the bodies. These woods are full. There are bright, moonlit bodies; there is light from some other, colder place. At another moment, there would be sweetness on this shore. At another moment, there would be an unmingled sweetness of air that sinks into the bright, moonlit waters. At this very moment, the moonlight touches the bodies on the shore and there is a deep stillness. There is a soft, silvery wind that drifts through the forest onto the shore. There are tall trees. There is mud and broken branches and mossy rocks and tree stumps and driftwood and a broken pile of bodies. There is a stillness here on the shore. There is lightning and then there is stillness. There are echoes that rush through the forest until they disappear. A mile above there is a tumbling. A mile above seems like some other, softer place. In the water of the lake, there is the bright reflection of moonlight. A cold light from somewhere other than here. Some light touches the dead. Some light carries us to some other, softer place. Some light fills us with hope and warmth. Some light lasts

forever. Some flames flicker out. Some waters carry bodies. Some waters are still. Somewhere in the velocity of the uproar there is a current of air. There is an unmingled sweetness that sinks into the forest. The shore is full of bodies. The blood as natural as mud. The gully and the soft, dark places of the forest and the glassy waters and the sunken bodies and the shore and the moonlight and the pink clouds and the muddy roots and the severed limbs and the soft, silvery wind and the taste of danger and the black rocks between the mounds of earth and the glittering stars and the falling leaves and the open air floating over the forest and the valley and the stream overflowing onto the banks and the tumbling water and the branching pathways and the wet leaves on the ground and nearly everything in between. Here, the rushing water washes bones and the waters of the river run into the mountain lake. When the sun is directly above us, a shadow from the canopy will spread over the lake, creating a dark current with a deep hue. When the sun is directly above us, these waters become healing waters. Tomorrow, the sun will be directly above us and we will be healed by these waters. When the sun is directly above us, these currents will flow silently into the dark parts of the lake. When the sun is directly above us. When light touches all of the soft, dark places. When light spreads like a wave through the forest. When the forest starts to break open. When trees collapse. When branches break. When bodies are covered over by the earth. When there is a deep, cool wind. When there is a current of air, there will also be quiet bodies whispering in the darkness. The forest sways in the soft, silvery wind. The broken branches are swept up in that current. There is the sound from the rushing water drifting through the air.

From somewhere deep in the forest there are voices again. Voices from bodies. Voices on the wind. From somewhere deep in the forest there are more soft bodies, more sharp objects, more breath in the air. As the air flows up from the deep, soft places of the forest, the sound of rushing water can be heard again. Distant sounds that come from the branching river. The broken river with the clear, upstream water runs through the forest beneath some low bushes. Branches bend in the current of this river. Some call this river by a name. For many moments, the branches curve in the eddies and the arm of the river turns towards itself. For many moments, the name of the river hangs in the air. Every few yards, bubbles appear on the surface, are filled with light and disappear. At the shore, there is a dead silence and then there are quiet voices. Somewhere under the ragged treetops is the growing sound of voices. Somewhere on the river, leaves can be seen floating along. There is a current that swells and sinks and crashes against the rocks, echoing through the vaults of forest and the sweetness of nature. Above the canopy, bodies can be seen drifting through the trees. There is quiet motion; there is breath. In the caverns below, there is air that rises up to meet those bodies. The bodies are just flesh drifting through the air. The air. The sparks. The flames. The smoke. The cool evening breeze sweeps through their fingers and between their antlers. Any breath. Any fire. Any thunder rumbling beyond the distant hills. Any surface. Any signal. Any water. Any alarm far down the current of the river. Which bodies can be trusted? Which breath sounds the sweetest? Which connections can be formed from these soft groupings of flesh? Which company will find their way out of this forest? Which dirt pathways will stretch

on endlessly into the forest? Which turns will be hazardous? The air sinks into the caverns below and the voices sink too. Which current glides towards fortune and which current turns treacherous? The river plunges into the ravine and the mist rises like smoke. For a few moments, the mist is the smoke before it falls back into the river. For a few moments, there is a plume of water crested by the light that cuts through the forest. Somewhere in the trees there are leaves falling onto a path. A path that winds through the trees and around the river. Behind the curvature of the path, there is a dark, wooded outline and a soft, silvery wind. The open heavens and the drifting vapours and the broken treetops and the sullen sounds and the evening atmosphere and the blazing fire and the deep laughter and the broken rocks and the roaring cavern and the rushing water and the impenetrable darkness and the water glimmering in the moonlight and the hills and the gloom and the moving surfaces and the quiet uneasiness and the wooded outlines and the silvery wind and the broken branches and soft, dark places in the forest. In this gully, there is a darkness that can only be tasted. Another tree. Another body. Another knot. Another notch. But which tree? Which body? Which knot? Which notch? Which soft expanse of trees? Which position of the sun? Which direction of the water? Which hesitation before speech? Which flesh enters into the river? Some say that all the knots of pine can be counted. Some say there will always be another mouth. When the fall wind rustles the leaves of the forest. When the dead listen. When there are no more noises. When the blood is hot. When black smoke drifts through the camp like a fog. When the vapours are inhaled. When the clouds settle onto the trees. When white lightning breaks open the sky above us.

When the forest bursts into flames. Somewhere in the gully there are naked bodies and soft voices and a wall of heat. Breath and silence and breath again. In the deepest hollow of the gully, there is fire. At the edge of the lake, there is a narrow, deep cavern in the rock. Some day bodies will spread over both sides of the lake. In the west, there will be as many bodies as there are leaves on the trees. In the fields, bodies bloom like fire. On the broad side of the trail, the air tastes like copper and the holy lake is full of bodies. Bodies and air and flesh and moonlight and breath and fire in the fields. Numberless bodies and songs and voices. Countless claws and horns and antlers. Tonight, the stars will shine. Tonight, the evergreens will grow. Bodies will spread out across the soft expanse of forest and beyond the horizon as seen through the branches of trees and the west will arrive. Above the pines, the sky is bright and pink and delicate. Where are the deep shadows? What forms out of the damp morning air? What bitterness? What glory? What country? The rippling stream bends towards every vista. The sun sets in a flood. Here, coolness spreads through the beach. The bodies and the broken masses of rock and the distant western hills and the spectacle of darkness and the pure exhalations of fall and the eastern shore and the north island and the mountains and silent moments and the shaggy outlines of the tall pines and nearly everything in between. From the woods. From the darkness. From the broken masses of rock. From the distant eastern hills. From the north. From the eastern shores that are barely visible in the heat of the afternoon comes a silence that burns like fire. From the southern end. From mountain to mountain. From the eastern bank of the lake. From eye. From body. From witness. From the bodies

that see themselves. From the dizzying heights. From the narrow sheets. From truth. From weakness. From speaking. From flame. From the air pouring across the waste waters. From light. From margin. From earth. From broken summits and broken sky. From the broken branches and the mossy rocks and the deep, narrow ravines. From the soft, dark places of the forest. From the blood spilling into the rivers. From the tumbling in the air a mile above us. Below the high and broken summits are countless islands and clear sheets of water running from shore to shore. After all the dirt trails winding through the trees. After all the low strands disappearing into the water and reappearing in parallel. After all the hills and the lakes. After all the waterfalls and mists and riverbeds. The morning will approach again tomorrow. From this spot, the bodies almost seem to disappear in the shimmering heat from the afternoon sun. Beyond the miles of unbroken water. Beyond the shores of the lakes. Beyond the danger. Beyond the eastern waters. Beyond the horizon are miles and miles of lakes that intersect and overlap, sharing vessels that glide along the currents. The chasms. The black waters. The shores. Somewhere along the horizon the earth disappears. For a few moments, there is no lake. There are no bodies. There are no mountains. There are no waters. There is no moon. There is no forest. There is only darkness. For just a moment, all the soft, dark places of the forest disappear into that darkness. When the light reappears, there are clouds in the sky. There are headlands dotted with countless islands. There are islands surrounded by other islands. There are cliffs and forests and rivers. Sometimes the elevation plunges. Sometimes the waters rise. Sometimes the bodies are no great distance. Sometimes the clouds

spill out across the sky. Sometimes there is the scent of roses. Sometimes there is white lightning in the sky a mile in the air above us. Sometimes fires die out. Somewhere deep in the woods there is a dark lake at the bottom of a mountain. There are slow waters here. There are echoes and rocks and fissures and bodies and mounds of earth and shrubs and little ponds and mossy stumps and broken bones and broken antlers. The air is heavy with mist. Branches sway in this air. The air floating and rising and cooling at the base of this mountain. If there is the taste of copper in the air. If there is scattered light from the brush above. If the air floats over the lake. If the west. If the voices. If the bodies. If the soft, silvery wind. If the rocks. If the trees. If the waters here are forever. If the waters here dry up. If the intermingling drifts of air stretch out to intersect with other winds. The bodies here in the lake are silent and still. Somewhere out there other bodies carry broken claws and fractured fingers. Somewhere waters rush through the woods, pulling down trees that stand too close to the shore. Limbs break in those currents, on those rocks. The bodies sink into the lake and resurface somewhere between the rocks and the driftwood and the light. For a moment, the moon is visible. In the heat of the afternoon, there is a bellowing from the rushing wind that rises up through the branches and the trees and the shrubs and the broken rocks. Beyond these trees there are just more bodies, just more flesh. Beyond these woods there are countless bodies that spill out into the forest and glide out endlessly into the horizon. Beyond these trees there are soft voices and light and other bodies and breath. Somewhere in the forest branches break. The air swells. What breaks open out of these sounds? What trust forms from breath? What bitterness hangs in the air? What bodies

fill the air with words? What flesh can stand this heat? What footsteps are covered over by the sound from the rushing wind? The rocks and logs and immovable mountains that are almost visible from miles away and the driftwood and the trees and the lake and the bodies. If the conversations are overheard, the bodies might break. If the bodies are silent. If there is light shining down on the flesh and the trees and the mossy rocks. If there are voices that cut through the wind. If the west hangs in the air on this breath, then the water must reflect the light from the moon at midnight. If the west is here at all, it is caught up somewhere in the uproar of sounds that come from the bodies in the trees, sounds that intersect with each other and cut softly through the silence. If the west is to be made, then the bodies will make it. For a few moments, the stars will light up a pathway that winds through the forest and past the lake and between the mountains. For a few moments, all bodies become lost in the smoke. Flames can be seen through the branches. Through the numberless branches and the broken tree limbs and the black rocks and the mounds of earth and the sea. Sometimes when the sun sets the waters from the lake will look like wildfire. But the sun is not setting and the water here only reflects the flames in the forest. Somewhere out there away from the shore there is a clear sheet of water and bald rocks just beneath the surface. Somewhere there is a tumbling in the air a mile above us. Sometimes these waters are full to the brim. Sometimes salt grows in these waters. The water in the lakes and the rivers and the streams and the waterfalls. Sometimes after all this fire there is the taste of copper in the air. Sometimes there is the taste of danger. On the shore, there are only bodies. On the shore, there is breath and there is fire.

At the furthest edges of the lake, there is another shore. Another quiet shore where there are as many bodies as there are trees. Here, there is light and stillness and glimpses of grey smoke billowing over the tops of trees in the distance. In the far distance, there is another clear sheet of water, another shore, another islet, another mouth. In the far distance, all the clouds of smoke seem to drift into each other, seem to drift through each other. Voices can be heard somewhere out in the forest. For all the fragments of driftwood along the shore. For all the dark mounds of earth and wet rocks and broken branches and intersecting lines of sight. For all the right angles that cut across each other until there is a moment when they intersect. For all the leaves falling to the ground in the swirling autumn breeze. For all the broken rocks and immovable trees and deep, narrow ravines and soft, dark places. For every cloud that breaks apart. For every leaf that falls from a tree. For every broken body. For every mound of flesh. For every limb. For every drop of blood. For every cheek pressed against the mossy trunk of a tree. Beneath the broken clouds is a steep, rugged descent and a trail of bodies spilling down into the forest and into the lake. There are no sounds anymore except for the crackling of the fire in the woods. There are no shores other than these shores. There are no bodies other than these bodies. There is no flesh other than this flesh. In earlier seasons, flowers would bloom on this shore by the woods overlooking the deep stillness of the lake. Today, the blood blooms in this water. Blood and salt and expanding sheets of dark water. Blood gushing from soft, delicate bodies. Blood floating through the water until it disappears. Blood sinking into the soft, dark places of the forest. Blood and dirt and rocks and branches and rainwater. There are

bodies sinking into the lake that look almost like a constellation of stars. Here, the soft, silvery winds push the water and bodies through the lake towards the dark, deep places. There is a blackness at the bottom of the lake that seems to absorb any light that might touch it. For a moment, the light from the bright, delicate afternoon and the light from the wildfire reach out to this dark place. For a moment, light touches a place it has never touched before. For a moment, the bodies in the lake are lit up again and the broken antlers and fractured fingers can be seen very briefly from the shore. For a moment, there is a soft opening for tired epiphany. For a moment, the flesh is remembered by the water. Beyond the curvature of the shore there is the dark, wooded outline of the forest. There is rain now in the dark sky and the fires have died out. There are only bright, glowing embers. Glowing orange and red chunks of wood that hiss momentarily in the downpour and slowly turn black and ashen. The smoke from the fire drifts out over the lake and through the forest. Between the trees and the leaves and the broken branches and the mossy rocks. If there is space here in the smoke for voices, then they are softer than before. If there is space for breaking, it is here and now in the rain overlooking the smoke on the dark lake. If there is space between the trees and the black rocks and the shrubs and the driftwood, it is filled with grey smoke and mounds of black earth. Somewhere above there is a tumbling in the air. Somewhere above there is a soft, silvery wind that disappears into the trees and cuts through the smoke. Some stars can be seen above the lake and through the broken canopy of smouldering trees. Somewhere above there is light from somewhere other than here. Some colder, darker place. Some bodies. Some branches. Some

limbs. Some voices from some other place. From somewhere under the deep stillness of the lake there is a current that rises up to meet the smoke. A current that cuts through the smoke and the cool water and ripples the lake. There is smoke here that drifts just above the surface. There are slow, intermingling drifts of darkness. There is a darkness here that can only be heard. Just above the expanse. Just above the reflections of the glittering stars. Just above the bodies with layers of matted fur and claws and soft voices. There is a darkness that drifts through the trees. There are bodies that move through the trees. There is flesh and there is darkness and there are moments when they seem to intertwine and exist only together as one. At this height, the shining stars are just a little closer. At this height, about a quarter mile from the base of the mountain, the sun lingers on the tops of trees. If there is a gust of wind that follows the curvature of the valleys and glides up to the black clouds eighty feet up in the air. If there is the taste of wilderness in the air on the southern shore. If the trees that have fallen in the river sink down to the riverbed. If the thousands of glittering stars above are never quite visible in the light from the afternoon. If the darkness here drifts through the night. If the rocks just below the surface can't quite be seen. If the bodies here are forever. If the lake stretches up like blood at the throat. If the water from the river flows silently into darkness. If there are leaves floating in the river. If the blood sprays into the air. If there are voices. If there are parallels between the tree branches. If the waters rise. If a line is drawn. If there are connections between the precipices. If there are no more hills or banks or caverns or ravines. If there is just flesh on the ground and in the mud. If the lake sometimes shines in the light from the sun in

the afternoon. If the bodies float down the stream. If there is the
taste of danger. If there are moments that intersect with other
moments. If the smoke consumes the forest. If the south bank
remains a point in space. If the bodies hang in the trees and above
the firepits. If a broken line branches into the east. If the light
between leaves is just moonlight. If the woods disappear into the
night. If there is old light and a bright mist and glassy rocks. If
there are caverns in the rocks that lead us into darkness. If there is
a memory of the sun after the woods grow dark. If there are ripples
in the lake water. If there is fear. If the blood runs like a river. If
bark is peeled from a tree. If slow, intermingling drifts of sounds
and scents float through the air. If the moon reflects the light from
the sun. If there are bodies and land and hunger and fire. If there is
a country. If there is a nation. If there is a howling wind in the
passageways between the broken rocks. If some other, softer place
is not softer at all. If some other, softer place is always just through
the trees. If blood gushes from every body. If the darkness never
lifts. If there is a tumbling in the air above us. If the bodies are
drained of blood. If the flesh becomes still. If there are steep
pathways between the rocks that lead up the mountain. If there are
bodies on those pathways. Bodies with antlers in the autumn sun.
Bodies reflected on the glassy surface of the water. Bodies with
fingers and mouths in the coolness of the night. In the coldest fall
nights, the mud will harden and freeze over. The bones in the earth
will crust over with frost. Some flesh is as solid as the mountains.
Some flesh protrudes from the frozen mud. Some flesh still carries
the lingering scent of roses. Some waters begin to freeze over. Some
waters become ice. Some frozen voices still cry out in the snowy

forest. There will always be voices. There will always be words. There will always be some idea of a country. There will always be a future. There will always be tomorrow. Tomorrow ripples outward across the water. Tomorrow spreads out horizontally along all the soft surfaces. Tomorrow, there will be silence. Tomorrow is a circle. Tomorrow is a line that cuts endlessly through the forest. Tomorrow is a dream that repeats again and again. In the frozen river, there is blood. There are broken bodies and broken bones in the ice. On the shore, there is a flat, black rock below the knee and above the hip bone and between the antlers. There is a skull resting on the frozen stump of a tree trunk. To remove the claws. To extract the fangs. To puncture the skin. To see the line that connects the fingers to the ribcage to the wing. The stars will puncture the darkness. The clouds will drift apart. The bones will freeze over. There is a clear sheet of ice and frozen bodies somewhere below the surface. The crisp air and the frozen bones and the silvery clouds and the blood and the icy rocks and the skulls and the cold of winter. Even when the sun is directly above the earth, there is still a coolness that spreads through the trees. When the light cuts through the brush. When the forest freezes over. When there is a moment. When the bones seem to disappear from eighty feet up in the air. When the air is cool and clear. When the bones are swallowed by the snow. When a soft, silvery wind rushes through the branches. When winter finally arrives.

*Celestial Objects*

# IV

When winter finally arrives. When a soft, silvery wind rushes through the branches and over the road. When the footpaths are hard and worn. When the air is cool and clear. When the town seems to disappear from seventy feet up in the air. When there is a moment. When the forest freezes over. When the lights from the village cut through the brush. When the sun is directly above the earth. When there is still a coolness inside the doors. The crisp air. The frozen bones in the forest. The silvery clouds. The light from the windows. The icy rocks. The blood on the leaves. The skulls at the bottom of the lake. The cold of winter. The breath and the laughter and the bright, shiny night. There is a clear sheet of ice and frozen bodies somewhere in the mud at the bottom of the lake. Outside, fur will crust over with ice. Fingers will thaw and rot. Ears will turn black and eventually fall off. The clouds will drift apart. The stars will puncture the darkness. To see the line that connects the knife to the fingers to the arm to the antlers. To puncture the skin. To extract the organs. To sift for gold. To see the skull in the snow on the frozen stump of a tree trunk. To see the carvings in the wood. On the shore, there is a flat, black rock between two halves of a body. There are broken bodies and broken bones in the ice. In the frozen river, there is blood. Tomorrow is a dream that repeats again and again. Tomorrow is a line that cuts endlessly through the

forest. Tomorrow is a circle. Tomorrow, there will be silence. Tomorrow spreads out horizontally along all the hard surfaces. Tomorrow might arrive on the roadway across the water. There will always be a roadway. There will always be a future. There will always be some idea of a country. There will always be words. There will always be voices. There will always be towns connected together by pathways of hard dirt and small, broken rocks. Somewhere out in the brush beyond the town there are frozen bodies crying out in the snowy forest. Somewhere in the cold brush there are bodies with fingers and claws and tails and mouths. Somewhere out there flesh is freezing in the biting wind from the mountain. Some mountain waters become ice. Some waterfalls freeze over. Some flesh carries the lingering scent of roses. Some flesh protrudes from the frozen mud. Some flesh becomes petrified. The bones in the earth will crust over with frost. In the winter, the mud will harden and freeze over. Bodies within bodies in the coolness of the night. Bodies intertwining. Bodies entangled in love and darkness. Bodies reflected on the glassy surface of the ice. Bodies in the darkness. If there are bodies on those roadways. If there are steep pathways between the rocks that lead up the mountain. If the flesh becomes still. If the bodies are drained of blood. If there is a tumbling in the air above us. If the darkness never lifts. If blood gushes from every body. If some other, softer place is always just down the road. If some other, softer place is not softer at all. If there is a howling wind in the passageways between the broken rocks. If there is a nation. If there is a country. If there are bodies and towns and broken land and hunger and fire and windows that look out onto the road. If the moon reflects the light from the sun.

If slow, intermingling drifts of sounds and scents float through the air. If bark is peeled from a tree. If the blood runs like a river. If there is fear. If there is sickness. If there are broken sheets of ice in the lake water. If there is the promise of warmth after the winter unfolds in the woods. If there are caverns in the rocks that lead us into darkness. If there is old light and a bright snow and icy rocks. If the woods disappear under the ice. If the light between the branches is just moonlight. If the broken lines come together again at the centre of town. If the bodies hang in the trees just past the outskirts. If the south seems like a dream. If the town is just a point in space. If the smoke consumes the forest and the roadways and the town. If there are moments that lead to other moments. If there is the taste of rot in the air. If the bones sink into the mud. If there is ever true darkness again. If the lake sometimes shines in the light from the campfires. If there is just flesh in the snow and in the frozen mud. If there are no more hills or banks or caverns or ravines. If there are connections between the precipices. If a line is drawn. If the ice breaks open. If there are parallels between the tree branches. If there are voices. If the blood sprays into the air. If there are leaves scattered along the dirt road. If the road branches silently into other roads. If there is blood at the throat. If the bodies here in this village are forever. If the scattered rocks in the dirt can't quite be seen in the darkness. If the darkness drifts through until the day breaks. If the thousands of glittering stars above are never quite visible in the light from the afternoon. If the trees that have fallen in the forest by the village are cleared away. If there is the taste of wilderness in the town. If there is a gust of wind that follows the curvature of the valleys and glides up to the black clouds seventy

feet up in the air. At this height, about a quarter mile from the base of the mountain, the sun burns the tops of trees. At this height, the shining stars are just a little closer. There is flesh and there are campfires and there are moments when they seem to intertwine and exist only together as one. There are bodies with antlers that walk through the trees. There is a darkness that drifts through the forest. There is water that hangs in the air on the drifts of darkness that brush the tallest trees in the forest. Just above the treetops, there are snowflakes that have found their way here after winding their way among countless islands, after turning to vapour in the blistering heat of the summer, after cutting through the air. Just above the treetops, there is a black, cold sky. Just above the treetops, there is the old light from old stars piercing the darkness. Just above the treetops, there is the scent of roses and whiskey. Just above the bodies, there are clouds of breath. Just above the glittering stars, there is an emptiness. Just above the expanse. Just above the darkness. Just above everything, there is a darkness that can only be heard. There are slow, intermingling drifts of darkness. Where there is smoke, there are bodies. Where there is fire, there are bodies. There is smoke here in the dark night. A night that drifts through the branches of the trees above and up to the canopy. A wind cuts through the trees. A trail of smoke drifts through the pine needles. The ripples in the frozen lake look as though they're always about to break. From somewhere under the deep, frozen lake. From somewhere in the dark water. From some other voice. From some other body. Some breath. Some wilderness. Some distance. Some ice. In the frozen wind, there is sometimes no way to tell what's smoke and what's snow. In the frozen wind above the icy

lake, there is some blood and some dirt and some silence. There are pieces of bark crusted with ice. There are pieces of bodies crusted with ice. There are limbs frozen into the lake alongside some branches and some dirt. In the coldest winds, some bodies can survive for just a few hours. Even in the cold wind on the frozen lake, there is some other colder, darker place. Somewhere above there is light from somewhere other than here. Some stars can be seen above the lake and through the broken canopy. Somewhere above there is a soft, silvery wind that disappears into the trees and cuts through the night. If there is space between the towns and the trees and the roads and the shrubs, it is filled with a soft, heavy darkness. If there is space for all these bodies, it is here in the snow overlooking the path that winds through the trees and down into the town by the lake. Between the trees and the broken branches and the icy rocks. The ice drifts out over the lake and crunches against the shore. There is ice falling from the dark sky and breaking apart the frozen sheets on the lake. Beyond the curvature of the shore there is the dark outline of the town. For a moment, the flesh is remembered by the forest. For a moment, there is a soft opening for the tired and the sick and the broken bodies of the earth to rest briefly behind closed doors. To rest briefly by a fire. For a moment, the bodies exist here in the town by the frozen lake. For a moment, the town and the lake are lit up by torches and fires and stoves. For a moment, the town can be seen from the other edge of the shore. For a moment, light touches a place it has never touched before. For a moment, the light from the town illuminates everything that surrounds it and the forest is not the dark place it used to be. For a moment, the only darkness that remains is at the bottom of the lake, a place that

seems to absorb any light that touches it. Here, the light disappears. Here, there is darkness. Above the town, there is a soft, silvery wind. In the woods, there are still frozen waters and icy bodies lost somewhere in dark, deep places. There are bodies with claws and fingers that are stuck there at the bottom of the frozen lake. Blood and snow and dirt and rocks and branches and ice. Blood sinking into the soft snow. Blood freezing to the surface of the lake water. Blood gushing from soft, delicate bodies. Each body softer than the last. Today, the air is crisp and cold and tastes like salt. Today, there are frozen sheets of dark ice colliding with the shore. Today, the blood blooms in this water. The water at the bottom of the lake. In earlier seasons, flowers would bloom on this shore by the woods overlooking the deep stillness of the lake. But in this season, there is just blood and snow and ice and dirt and soft, delicate bodies between the trees. Today, there is no flesh other than this flesh. There are no bodies other than these bodies. There are no shores other than these shores that crunch with ice. There are no sounds anymore except for the crackling of the fire in the woods. Beneath the broken clouds is a steep, rugged descent and a trail of bodies spilling down into the frozen lake. For every cheek pressed against the snowy trunk of a tree. For every drop of blood. For every cracked antler. For every mound of flesh. For every broken finger. For every leaf that has fallen from a tree. For every cloud that breaks apart. For every flake of snow. For all the broken rocks and immovable trees and deep, narrow ravines and soft, dark places. For all the leaves that have fallen to the ground. For all the right angles that cut across each other until there is a moment when they intersect. For all the dark mounds of earth and icy rocks and

broken branches and intersecting lines of sight. For all the frozen chunks of driftwood along the shore. Voices can be heard somewhere out there in the storm. In the far distance, there is more smoke, more snow, more wind. All the clouds of smoke, all the drifts of snow, seem to intertwine with each other. In the far distance, there is another clear sheet of ice, another frozen shore, another islet, another mouth, another body gushing blood in the snow. Here, there is darkness. Here, there is a stillness. Here, there are glimpses of grey smoke billowing over the tops of trees in the distance. On another quiet shore. On another quieter, softer shore, there are no bodies. No blood. No frozen fingers in the crusted mud. On the edge of another forest, there are quiet voices and calm fires and cooked flesh and laughter and a cold wind. On this shore, there is short breath and burning fire. There are so many voices. On the shore, there are piles of bodies. The bodies are frozen together. The matted fur is sticky with blood. The flesh pressed up against other flesh out there in the snow. Sometimes there is the taste of copper in the air. Sometimes after all this blood there is just the sound of the wind. All the waters are frozen. The water in the lakes and the rivers and the streams and the waterfalls is full of ice. Sometimes these waters break apart. Sometimes the ice finds its way to the shore. Somewhere out there above the frozen lake there is a tumbling in the air. Somewhere out there away from the shore there is a clear sheet of ice and bald rocks just beneath the surface. Today, the sun is rising and lighting up all the piles of bodies by the frozen lake. The snow swirls around those bodies. Today, when the sun sets. Today, when there are just memories of wildfire. Today, when the frozen water is covered over with snow. When there are

numberless branches and broken tree limbs and black rocks and mounds of earth and chunks of ice. Today, there is a flame. Today, smoke can be seen through the branches. All bodies become lost in the smoke. For a few moments, the stars will light up a pathway that winds through the forest and past the frozen lake and between the mountains. If the west is to be made, then this flesh will make it. There are bodies. There are bodies that have voices. There are bodies that have voices and fingers and claws and antlers. There are bodies that have voices that overlap. There are bodies that make the west. There is flesh that makes the west. If the west is right now, it is caught up somewhere in the uproar of voices that come from the bodies in between the trees. If the west is right now, it hangs in the air on this breath. If the west is right now, then the ice water must reflect the light from the moon at midnight and the flesh must witness it. If there are voices that cut through the wind. If there is light shining down on the flesh and the trees and the frozen snow on the ice. If the bodies are silent. If the flesh remains soft and delicate. If the conversations are overheard, the flesh might break apart. The bodies might gush with blood. What world erupts out of this silence? What trust forms from breath? What bitterness hangs in the air? What bodies fill the air with words? What bodies can stand this cold? What footsteps are covered over by the drifting snow and the rushing wind? What country is formed by these bodies? What nation cuts through this fog? Rocks and logs and immovable mountains and frozen chunks of driftwood and broken tree branches and icy lakes and piles of bodies and a soft, silvery wind. The air swells. Somewhere in the forest branches break. Beyond these trees there are soft voices and light and other bodies

and breath. Beyond these woods there are countless bodies that
spill out into the forest and glide endlessly into the fires of the road.
Beyond these trees there are just more bodies with matted fur and
broken toes. Beyond these trees there is a spark in the air. There is
a spark on the tip of every tongue. Beyond these trees there is a
bright, shiny day and there are bodies. In the chill of the evening,
there is the sound from the rushing wind that rises up through the
branches and the trees and the shrubs and the broken rocks. For
a moment, the sound from the wind is the only thing that can be
heard in the town. For a moment, the moon is visible. For a moment,
the moon is directly above us in the sky. For a moment, the frozen
piles of bodies by the lake are forgotten. In the morning, the bodies
will surround the lake. In the morning, other bodies will appear. In
the morning, there will be other flesh, other voices in the light that
cuts through the snowy trees. There will be bodies between the
rocks and the driftwood and the broken branches. Branches will
break under those bodies. Bodies will be broken on those rocks.
Somewhere swirling snow rushes through the woods, pulling down
the branches that are too frail. All the bodies here are broken. All
the flesh can be forgotten. The bodies here by the shore of the icy
lake are silent and still. If the intermingling drifts of air above
stretch out to intersect with other cold winds. If the frozen waters
here become covered over with snow. If the frozen waters here are
forever. If the trees. If the rocks. If the soft, silvery wind. If the
bodies. If the voices. If the west. If the broken antlers. If the air
floats over the lake. If there is scattered light from the brush above.
If there is the taste of copper in the air. If there are piles of frozen
bodies. If there is room for breathing. If there are roadways full of

fire that run from town to town. If the air floating over the frozen lake is sinking at the base of this mountain. Branches sway in this air. The air is heavy with ice. There are echoes and rocks and fissures and bodies and mounds of earth and shrubs and frozen little ponds and mossy stumps and broken bones and broken bodies. There are slow waters here choked with ice. Somewhere deep in the woods there is a frozen lake at the bottom of a mountain. Sometimes fires die out. Sometimes there is white lightning in the air above us. Coolness spreads through the town. The sun sets in a flood. The roadways are lit with fire. Where are the deep shadows in the tall grass? What forms out of the damp morning air? What bitterness? What glory? What country? What bodies? The frozen stream bends towards every vista. Above the pines, the sky is bright and pink and delicate. Bodies will spread out across the soft expanse of forest and beyond the western horizon as seen through the branches of trees and the west will arrive. Tonight, the evergreens will grow. Tonight, the stars will shine. Numberless bodies and songs and voices. Bodies with claws and wings and eyes and fingers in the moonlight. Bodies in the towns. On the broad side of the road, the air tastes like copper and the frozen lake is full of bodies. On the road, bodies move like fire. In the west, there will be as many bodies as there are leaves on the trees. Some day bodies will spread over both sides of the lake. At the edge of the lake, there is a narrow, deep cavern in the rock. In the deepest hollow of the snowy gully, there is fire. Breath and silence and breath again. Somewhere in the gully there are naked voices and a wall of heat. When the forest bursts into flames. When white lightning breaks open in the sky above us. Behind the curvature of the path, there is a dark outline of a town

and a soft, silvery wind. A road that winds through the trees and around the river. Somewhere in the trees there is snow falling off the branches. For a few moments, there is a shaft of light that cuts through the frozen waterfall, refracting a multitude of shifting blues and greens and purples onto the white snow. For a moment, the light shines through the ice. Which road turns towards fortune? Which road leads to treachery? Which bodies can be trusted? Which towns have the right collection of flesh and voice? Which breath sounds the sweetest? Which connections can be formed from these soft groupings of flesh? Which company will find their way out of this forest? Which roadways will stretch on without ending? Which towns will be hazardous? The air sinks around the crossroads and the voices sink too. Any alarm far down the road. Any voice. Any surface. Any thunder rumbling beyond the distant hills. Any fire. Any breath. The cool evening breeze sweeps around the bodies. The smoke. The flames. The sparks. The air. The bodies are just flesh drifting through the air. In the town below, there is air that rises up to meet those bodies. There is quiet motion; there is breath. Above the rooftops, bodies can be seen drifting through the roads. In the forest, there is a frozen river that winds through the broken rocks and the vaults of forest and the sweetness of flesh. The far down current, frozen again beneath the air. The downstream current. Somewhere on the river broken branches can be seen freezing into the ice. Somewhere under the ragged treetops is the growing sound of voices. Somewhere under the ragged treetops there are bodies and there are voices. At the edge of the river, there is a dead silence and a broken bridge. Every few yards, broken pieces of wood from the bridge appear on the frozen surface. For

many moments, the name of the river hangs in the air. For many moments, the bodies struggle to move over the ice. Some bodies call this river by a name. Some flesh speaks to this name. Some sounds in the air are just noise. Branches wave in the soft, silvery wind. The broken bridge. The frozen river. The ice and the snow and the low bushes in the forest. In the distance, there is the sound of ice cracking. As the air flows up from the deep, soft places of the forest, the sound of the cracking ice can be heard clearly. From somewhere deep in the forest there are more soft bodies with sharp claws breathing in the air. From somewhere deep in the forest there are voices again. From somewhere deep in the forest there is the sound of wind rustling the branches of the trees. The broken branches. The fallen needles. The snow. The winter is swept up in this sound. Sometimes the forest is nothing more than this sound. When there is a current of air. When there is silent motion. When there is a deep, cool wind. When bodies are covered over by the snow and the ice. When branches break. When trees collapse under the weight of the heavy, wet snow. When the darkness drifts through the forest like a wave. When the rivers of ice branch into the darkest parts of the lake. Tomorrow, the sun will be directly above us and we will be healed by these waters; but tomorrow isn't here yet and the river of ice just branches into the dark lake. When the shadow from the canopy spreads over the lake, creating a dark current with a deep hue. When the swirling snow covers over the bones and the rivers of ice run into the mountain lake. The snowy gully and the soft, dark places of the forest and the glassy ice and the sunken bodies and the shore and the moonlight and the black clouds and the frosted roots and the severed limbs and the soft, silvery wind

and the black rocks between the mounds of earth and the glittering stars and the open air floating over the forest and the valley and the icy stream and the frozen sheets of water and the branching pathways and the dead leaves and nearly everything in between. On the shore, there are piles of bodies. There is an unmingled sweetness that sinks into the forest. Somewhere in the velocity of the uproar there is a current of air. Some snow is still. Some ice carries bodies. Some flames flicker out. Somewhere in the darkness there is a soft, silvery wind. Somewhere up in the darkness there is the scent of roses. Some light lasts forever. Some light fills us with hope and warmth. Some light carries us to some other, softer place. Some light touches the dead. Some darkness seems to last forever. Tomorrow, there will be a cold light from somewhere other than here. Tomorrow, a cold light will shine down onto the shore, onto the piles of frozen bodies. Tomorrow, the clear expanse of ice will reflect the cold light of the sun directly in the sky above us. A mile above us, seems like some other, softer, colder place. A mile in the air above us, there is a tumbling. There are echoes that rush through the forest until they disappear. There is lightning and then there is stillness. There is a stillness here on the frozen shore. There is hardened mud and broken branches and icy rocks and tree stumps and driftwood and a frozen pile of bodies with matted fur and claws and fingers. There are tall trees. There is a soft, silvery wind that drifts through the forest onto the shore. At this very moment, the cold light from the sun touches the frozen piles of bodies on the shore and there is a deep stillness. At another moment, there would be an unmingled sweetness of air that sinks into the frozen waters. At another moment, there would be sweetness on this shore. At another moment, there would be joy and warmth

on this shore. Today, there are just bright, frozen bodies. Today, there is a light from some other, colder place. Today, these woods are full. At this moment, the light hangs in the air just above the frozen piles of bodies. At some point, the moonlight touches the ice and the broken bodies. Somewhere in the afternoon there is a deep stillness. Somewhere there is the sound of ice breaking apart. Gliding above somewhere up in the cold light is the scent of roses. These woods are full of bodies and bones and snow and trees and broken branches and dead leaves and soft, silvery wind. These shores are full of throats that have been cut, limbs that have been severed, blood that has been frozen. The woods and the bodies and the cold light and the breaking ice. The sharp reflections. The swirling snow. The clouds of breath in the air. There is a soft mist floating just above the surface of the frozen lake. There is a soft mist drifting through the trees. There are icy rocks and deep shadows and dead leaves in the forest. In the short distance between the lake and forest, there is a shore. On this shore, the frozen bodies clump together and the stench carries up into the air. The frozen lake stretches out horizontally until the edges touch the shores and the cold light cuts through the afternoon like a knife at the throat. The frozen water in the woods and on the lakes and in the higher parts of the sea. There are frozen bodies here on the shore and in the ditches by the road and in the tall snowy grass and underneath floorboards and buried just outside of town. In six hours, the snow will cover over all the bodies and the lake and the forest. In six hours, the wind will make this place disappear. In the town, the bodies are not easily forgotten. On the road, the bodies will never be missed. There is a fierceness in this town. There is a

fierceness here at the crossroads. There are frozen bodies and swirling snow and speaking mouths and a cold light from the sun. There is a cold light spreading over the hard expanse of the town. Somewhere above the light from the sun turns the clouds red and purple and orange. There are moments when the cold light stretches out across the horizon and fills up the sky. There is a bellowing somewhere in the forest that reaches the edge of the town. Little houses and shacks and a hitching post and a roadway that shoots through the town, piercing the afternoon. Mounds of frozen bodies and broken trees. In the forest, there are icy rocks and logs and a river of ice that cuts through the trees. In the town, there are slow, intermingling drifts of bodies that brush up against each other during the day. In the town, there are hard, cold places made for bodies. In the town, there are spaces for light and for sound. Just above the rooftops, there is an overlapping space of sounds and scents and colours. The upper air—where it drifts over the tops of the ragged rooftops—is full of sounds. This town is full. In this town, the scent from the bodies intersects with the scent of roses floating above somewhere up in the air. In this town, the bodies cut other bodies. In this town, there is silence for just a minute or two. In this town, the bodies are ragged with scrapes and bruises and broken fingers and dead ears. In this town, the flesh will split again and again. There is firelight and jagged scars and the taste of copper in the air. Above this place, there is a deep hollow in the sky and there is the scent of roses in the air. In this roadway—the road that splits open again and again—there are frozen bodies in the ditch. At this very moment, the hollow space in the sky is filled with air and just becomes more empty space between towns. In some

parts of the road, though, there are more bodies. The road breaks apart again and again until there is barely a path connecting each town. In the town, there are fractured roads. There are sometimes great expanses of buildings and pathways and construction. In between the roads, there are sometimes mounds of earth. The roads connect themselves to other roads, other pathways, other trails, other towns. In the forest, there are hollows and ravines and frozen rivers. In the snowy forest, there are deep, soft places. There are towns and forests and straits and islets and roads and rocks and somewhere in the air is the scent of roses. Somewhere there is an islet and another islet and a clear sheet of ice and bald rocks just beneath the surface. Among the icy rocks and the broken tree branches, there are mounds of black earth and other rocks and other frozen driftwood. Somewhere out there, at some reasonable distance, are scenes of white snow and nature and glimpses of mountain ranges that disappear just as suddenly as they appear. Somewhere out there is the wilderness. Somewhere out there is the open, sprawling land; somewhere out there is the open, sprawling town. Somewhere out there is the taste of copper. Somewhere out there is another town, another river, another mouth, another road. Somewhere out there is the scent of roses. Somewhere out there is a road that cuts by the icy rocks and the frozen lake. From the frozen lake, there is a steep, rugged ascent up the mountain. There are glimpses of towns and bodies and roads from the mountain. There are broken branches and the scent of roses and snowy expanses and tree stumps and dead leaves. Some seventy feet in the air there is no danger; there is only the broken and the splintered and the view of the open land sprawling with towns and roads and bodies.

Sometimes the water flows around these towns. Sometimes the water cuts through the towns. Sometimes right angles cut through the forest. Sometimes right angles run parallel to the river. Sometimes seventy feet up in the air there is just light and clouds and frozen droplets of water. Somewhere, deep in the snow gully, there is a soft, dark place. There is nothing here that breaks apart. There are no shapes here other than the trees. A snowy gully with a dozen branching pathways to follow. In the forest, there is a deep hollow. At this very moment, white lightning breaks open the sky and runs straight through the open heavens into some other place. At this very moment, there is lightning and then there is a tumbling in the air a mile above us. Sometimes there are other, softer places. Sometimes there are towns that sprawl out across the land. On the edge of the town, a river cuts through. On the river's edge, there are icy rocks and roots and hardened mud and tree stumps and broken bones and broken branches. On the river's edge, there are empty windows and crushed rocks and burned-down shacks and an icy ditch that leads down into some other, darker place.

# V

On the river's edge, there are empty windows and crushed rocks and burned-down shacks and an icy ditch that leads down into some other, darker place. On the river's edge, there are black rocks and hardened roots and mud and tree stumps and broken bones and broken branches. On the edge of the town, a river cuts through, dividing the bodies from the trees. Sometimes there are towns that sprawl out across the land in the bloom of spring. Sometimes there are other, softer places. At this very moment, there is lightning and then there is a tumbling in the air a mile above us. At this very moment, white lightning breaks open the sky and runs straight through the open heavens into some other place. In the forest, there is a deep hollow. A rainy gully with a dozen branching pathways to follow. There are no shapes here other than the trees. There is nothing here that breaks apart except the snow. Somewhere, deep in the wet gully, there is a soft, dark place. Sometimes eighty feet up in the air there is just light and clouds and droplets of water. Sometimes right angles run parallel to the river. Sometimes right angles cut through the forest. Sometimes the melting ice cuts through the towns. Sometimes the water flows around these towns. Some eighty feet in the air there is no danger; there is only the broken and the splintered and the view of the open land sprawling with towns and candlelight and drunken bodies. There are broken

branches and broken bodies and the scent of roses and rainy expanses and tree stumps and sprouting leaves. There are glimpses of towns and bodies and roads and lights from the mountain. From the lake, there is a steep, rugged ascent up the mountain. Somewhere there is a road that cuts by the black rocks and the lake. Somewhere out there is the scent of roses. Somewhere out there is another town, another river, another mouth, another road, another light. Somewhere out there is the open, sprawling land; somewhere out there is the open, sprawling town glittering with lights in the rainy darkness. Somewhere out there is the wilderness. Somewhere out there, at some reasonable distance, are scenes of melting snow and nature and glimpses of mountain ranges that disappear just as suddenly as they appear. Among the black rocks and the broken tree branches, there are mounds of black earth and other rocks and little houses with bright lights. Somewhere there is an islet and another islet and a broken sheet of melting ice and bald rocks just beneath the surface. There are towns and forests and straits and islets and roads and rocks and somewhere in the air is the scent of roses. In the forest, there are deep, soft places. In the forest, there are hollows and ravines and rushing rivers. The roads connect themselves to other roads, other pathways, other trails, other towns. The roads connect themselves to bodies and lights and taverns and blood. In between the roads and drunken bodies, there are sometimes glittering puddles of brown water that reflect the light of the stars. There are sometimes great expanses of lights and buildings and pathways and construction and sweaty bodies. In the town, there are fractured roads. In the town, the road sometimes breaks apart again and again until there is barely a path connecting

each house, each tavern, each body. In some parts of the town, there are countless bodies. In other parts of the town, there are bodies with claws and matted fur and broken antlers. Numberless bodies under the stars. At this very moment, there is a hollow space in the dark spring sky that is filled with air and clouds and noise. There is a stretch of rainy sky that reaches out between towns. On this roadway—the road that splits open over and over again—there are bodies. Above the bodies, there are lights. In the ditch, there are crushed rocks and dead bodies. Above this place, there is a deep hollow in the sky and there is the scent of roses in the air. Below this place, there is a deep hollow in the earth. In the town, there is firelight and jagged scars on burned bodies and the taste of copper in the air. In this town, the flesh will split open again and again. On this flesh, scars will form on top of scars. In this town, the bodies are ragged with scrapes and bruises and broken fingers and dead eyes. In this town, there is silence for just a minute or two. In this town, the bodies cut other bodies. In this town, the scent from the bodies intersects with the scent of roses floating above somewhere up in the air. This town is full of drunken bodies and sharp knives. The open air, where it drifts past the bodies, is full of sounds and scents. Just above the town—just above the rooftops—there is an overlapping space of sounds and scents and colours. In the town, there are spaces for flesh and for light and for sound. In the town, there are hard, cold places made for bodies. In the town, there are slow, intermingling drifts of bodies that brush up against each other. In the forest, there are still black rocks and logs and a river of melting ice that cuts through the trees. Mounds of decaying bodies and broken trees sinking into the earth. Little houses and shacks

and a hitching post and a roadway that shoots through the town, piercing the rainy spring day. There is a bellowing somewhere in the forest that reaches the edge of the town. There are moments when the cold light stretches out across the horizon and fills up the sky. Somewhere above the light from the sun turns the clouds red and purple and orange. There is a cold light spreading over the hard expanse of the town. There are bodies and soft rain and a light from the sun behind grey clouds. There is a fierceness here in the town square. On the road, the drunken bodies will never be missed. In the town, the bodies are easily forgotten. In the light from the streets, the bodies can appear for a second and then disappear again into darkness. In six hours, the town will disappear into darkness for just a few hours. In six hours, the town will reappear again in the cool morning light. There are rotting bodies here on the shore and in the ditches by the road and in the tall grass under the melting snow and somewhere beneath the floorboards and buried out in the woods. There is cold water in the woods and on the lakes and in the higher parts of the sea. The lake stretches out horizontally until the edges touch the shores and the cold light cuts through the morning like a sharp knife at the throat. On this shore, the rotting bodies clump together and the stench carries up in the warm breeze of the afternoon. In the short distance between the lake and forest, there is a shore. There is a shore at the base of the mountain where broken bodies clump together. There are black rocks and deep shadows and dead leaves in the forest. There is a soft mist drifting through the trees. There is a soft mist floating just above the surface of the melting lake like clouds of breath in the morning air. The melting snow. The sharp reflections. The woods

and the bodies and the warm light and the broken ice. These shores are full of bodies that have been cut, limbs that have been severed, blood that has disappeared into the wet, black earth. These woods are full of bodies with fingers and claws and dead eyes and broken wings. Gliding above somewhere up in the warm light is the scent of roses. Somewhere there is the sound of ice washing onto the shore. Somewhere in the afternoon there is a deep stillness. The spring rain touches the ice deep in the forest. At this moment, the rain hangs in the air just above the thawing piles of bodies. Today, these woods are full. Today, there is a light from some other, warmer place. Today, there are bright, decaying bodies. At this moment, there is joy and warmth in the air. At another moment, there would be ice on this shore. At another moment, there would be a cold wind swirling over the frozen waters. At this moment, there is a stillness. At this very moment, the warm light from the sun touches the decaying piles of bodies on the shore and there is a deep stillness. There is a soft, silvery wind that drifts through the forest onto the shore. There are tall trees. There is hardened mud and broken branches and black rocks and tree stumps and driftwood and a decaying pile of bodies. There is a stillness here on the shore. There is lightning and then there is stillness. There are echoes that rush through the forest until they disappear. A mile in the air above us, there is a tumbling. A mile above us seems like some other, softer, colder place. Tomorrow, the clear expanse of lake water will reflect the light of the sun directly in the sky above us. Tomorrow, a light will shine down onto the shore, onto the pile of decaying bodies. Tomorrow, there will be a warm light from somewhere other than here. Somewhere other than this warm, rainy place. Some rain

seems to last forever. Some rain touches the dead. Some rain carries us to another softer place. Some rain fills us with hope and warmth. Some rain lasts forever. Somewhere up in the darkness there is the scent of roses and the sound of soft water falling from the sky. Somewhere in the darkness there are soft, silvery drops of rain. Some flames flicker out in the lightest mist. Some flames die out in the softest rain. Some water carries bodies. Some water is still. Somewhere in the velocity of the uproar there is a current of air. There is an unmingled sweetness that sinks into the green forest. On the shore, there are piles of decaying bodies. The blood disappearing into the wet, black earth. The rainy gully and the soft, dark places of the forest and the expanding waters and the sunken bodies and the shore and the moonlight and the black clouds and the black roots and the severed limbs and the soft, silvery wind and the rocks between the mounds of earth and the glittering stars and the open air floating over the forest and the valley and the stream and the clear sheets of water and the branching pathways and the dead leaves and nearly everything in between. When the swirling rain covers the towns and the rivers and the roadways and the ditches and the mountain lake. When the shadow from the town spreads over the soft expanses of forest. When the town shadows the lake, creating a dark current with a deep hue. Tomorrow, the sun will be directly above us, casting dark shadows that stretch out down the street. Tomorrow, we will be healed by these shadows; but tomorrow isn't here yet and the shadows just stretch out endlessly until they disappear into the night. When the shadows branch into the darkest parts of the night. When the darkness is directly above us. When the sun is nowhere to be seen.

When darkness touches all of the soft places of the town. When the darkness drifts between the bodies like a wave. When the bodies break open. When the roof collapses under the weight of a pool of rain. When the windows shatter. When the floorboards split apart. When the bodies are buried under broken wood and broken glass. When there is a deep, cool wind. When there is silence for a moment in the town. When there is a current of air. When the town is swept up in this sound. The sound of the rain and the broken bodies. The broken stone slabs. The cracked beams of wood. From somewhere at the edge of the town there is the sound of wind whistling through the broken buildings. From somewhere deep in the town there are voices again. From somewhere deep in the town there are more soft bodies, more sharp objects, more breath in the air. As the air flows up from edges of the town, the sound of the soft rain can be heard clearly. In the distance, there is the sound of thunder. The rain and the bodies and the low bushes by the ditch. The flowing river. The broken bridge. The branches swaying in the soft, silvery wind. Some sounds in the air are just noise. Some bodies speak the name of this town. Some bodies listen from the forest. Some bodies call this moment by a name. For many moments, the bodies struggle to move across the bridge that extends over the river. For many moments, the name of the river hangs in the air. Every few yards, broken pieces of wood from the bridge float along on the surface. At the edge of the river, there is a dead silence and a broken bridge. Somewhere under the ragged treetops that line the edge of the forest there are bodies and there are voices spilling out of the town. Somewhere under the ragged treetops is the growing sound of laughter. Somewhere on the river broken branches can be seen

sinking into the water. The water sinking downstream. On the edge of the forest, there is a river that winds around the town and the broken rocks and the crooked roadways and the bruised flesh. Above the rooftops, bodies can be seen drifting into the forest. There is movement; there is breath. In the town, the bodies fill up the air with voices and fire and smoke. There are bodies drifting through the spring air, weaving their way through the broken rocks on the road. There are crushed, broken rocks and a road that winds through the town and across the bridge and into the ragged forest. The air. The sparks. The flames. The smoke. The cool evening breeze sweeps around the bodies. Any breath. Any fire. Any thunder rumbling beyond the distant hills. Any surface. Any body. Any voice. Any flesh moving through the town. Moving through the forest. Any flesh moving in the trees. Which bodies will find each other? Which bodies lead each other towards violence? Which voices can be trusted? Which towns have the right bodies? The right voices? Which voice sounds the sweetest? Which connections can be formed from these soft groupings of flesh? Which clusters of flesh will find their way out of this forest? Which roadways will stretch on without ending? Which towns will burn to the ground? The air sinks around the ragged trees at the edge of the forest and the voices sink too. For a moment, the light shines through the tree branches. For a few moments, there is a shaft of moonlight that cuts through the forest and into the river, illuminating a multitude of shifting whites and blues on the shallow surface. Somewhere in the trees there are bodies moving slowly. There is a road that cuts through the trees and around the river. Behind the curvature of the road, there is a dark outline of a town and a soft, silvery wind. The

open heavens and the drifting vapours and the broken treetops and the roadways and the sullen sounds and crushed rocks and the evening atmosphere and the blazing fire and the deep laughter and the cold town and the roaring cavern and the rushing water and the impenetrable darkness and the water glimmering in the moonlight and the hills and the gloom and the moving surfaces and the bodies and the quiet uneasiness and the wooded outlines and the silvery wind and the broken branches and soft, dark places in the forest. In this rainy gully, there is a darkness that can only be tasted. Another nation. Another lake. Another gully. Another cluster of bodies. Another fire. Another town. Another tree. Another voice. Another knot. Another road that cuts through another forest. But which other forest? Which other road? Which other fire burning between the trees? Which other body? Which other town? Which other country? Which other endless expanse of road? Which knot on which tree? Which soft expanse of sky? Which position of the sun? Some say that all the knots of pine can be counted. Some say there will always be another mouth. Some say there will always be another body, another town, another fire, another death. When the spirits brush past the trees in other forests. When the dead can be heard. When there is a soft, silvery wind. When the blood is hot. When black smoke drifts through the town like a fog. When the vapours are inhaled. When the clouds settle onto the trees. When white lightning breaks open the sky above us. When the town bursts into flames. Somewhere in the town there are naked bodies and crying voices and blistering fire. There is breath and silence and breath again. In the deepest parts of the town, there is fire. At the edge of the town, there is a narrow, deep river that separates the

town from the forest. Some day bodies will journey over both sides of the river. In the west, there will be as many bodies as there are leaves on the trees. On the road, bodies move like fire. On the broad side of the road, the air tastes like copper and the forest lake is full of bodies. Bodies and air and flesh and moonlight and breath and fire in the towns. Numberless bodies and songs and voices. Tonight, the stars will shine. Tonight, the evergreens will grow. Bodies will spread out across the expanse of the town and beyond the western horizon as seen through the branches of trees and the west will arrive. Above the trees, the sky is bright and pink and delicate. Where are the deep shadows in the tall grass? What forms out of the damp morning air? What bitterness? What glory? What country? What bodies? The forest stream bends towards the town. The roadways are lit with fire. The sun sets in a flood. Tonight, coolness spreads through the town. From the bodies and the broken masses of rock and the distant western hills and the spectacle of darkness and the pure exhalations of spring and the eastern shore and the north island and the mountains and silent moments and the shaggy outlines of the tall pines and nearly everything in between. From the woods. From the darkness. From the broken masses of rock. From the distant hills. From the north. From the flesh on the shores. From the southern end. From mountain to mountain. From the flesh on the bank of the lake. From eye. From claw. From crushed rocks and crooked roads. From the flesh that sees itself. From the dizzying heights. From the narrow sheets. From truth. From weakness. From speaking. From flame. From the air pouring across the waste waters. From starlight. From rain. From earth. From broken summits and broken sky. From the broken branches

and the mossy rocks and the deep, narrow ravines. From the soft, dark places of the forest. From the blood spilling into the river water. From the tumbling in the air a mile above us. Below the high and broken summits is a clear sheet of water running from shore to shore. After all roadways winding through the trees. After all the low strands disappearing into the water and reappearing in parallel. After all the hills and the lakes and roads. After all the rain and the fog and the wet mud. The bodies will approach again soon. The flesh will arrive again. From this spot, the sun always seems to be directly above the bodies. From this spot, this flesh seems to be a part of the earth. From this spot, the pile of bodies almost seems like part of the shore in the afternoon sun. There are miles and miles of rivers stretching through the broken forest. Beyond the rivers. Beyond the danger. Beyond the west. Beyond the horizon are miles and miles of towns that stretch into each other, that connect to each other with paths of crushed rocks and shallow ditches and candlelight and drifting bodies. The bodies and the road and chasms and the ragged treetops and the black waters and the shores and the horizon and the wet mud and the disappearing trees and the crushed rocks and firelight and the voices and the silence. For a few moments, the earth disappears underneath the bodies. For a few moments, there are just the towns and the roads and the fires. For a few moments, there is no forest. There is no lake. There are no bodies. There are no mountains. There are no waters. There is no moon. For a moment, there are no ragged treetops. There is only the town. A sprawling drift of darkness. All the soft, dark places of the forest disappear. When the light reappears in the morning, there are pink and orange clouds in the sky. Beyond the forest there are headlands dotted with

countless islands. Beyond the forest there are islands surrounded by other islands. Beyond the forest there are cliffs and forests and rivers and chasms and low bushes and the scent of roses. Sometimes the elevation plunges. Sometimes the waters rise. Sometimes the bodies are no great distance. Sometimes the clouds spill out across the sky. Sometimes there is the taste of copper in the air. Sometimes there is white lightning in the sky. Sometimes there are bodies that lose themselves in the forest. Sometimes fires die out. Somewhere deep in the woods there is a dark lake at the bottom of a mountain. There are slow waters here. There are echoes and rocks and fissures and bodies and mounds of earth and shrubs and little ponds and mossy stumps and broken bones and broken antlers and soft rain. The air is heavy with mist. Branches sway in this air. If the air floating over the lake is rising and cooling at the base of this mountain. If there are roadways full of fire that run from town to town. If there is room for breathing. If there are piles of bodies being reclaimed by the earth. If there is the taste of copper in the air. If there is scattered light from the brush above. If the air floats over the lake. If the flesh. If the west. If the voices. If the bodies. If the soft, silvery wind. If the rocks. If the trees. If the waters here are forever. If the waters here disappear into the rain. If the intermingling drifts of air above stretch out to intersect with other currents. If the bodies here are forever. If the towns are forever. If the roads of crushed rocks drift out and intersect together. If the forest is still, all the flesh can be forgotten. All the bodies here are broken. Somewhere in the spring light there is a downpour of rain that soaks through the woods. At some point, the rain will stop. At some point, the forest will stop. At some point, bodies will break.

At some point, the forest will break too. There will be bodies between the rocks and the driftwood and the broken branches. In the morning, there will be other voices in the light that cuts through the trees. In the morning, other bodies will appear. In the morning, the bodies will surround the lake. For a moment, the piles of bodies by the lake are forgotten. For a moment, the moon is directly above us. For a moment, the moon is visible. For a moment, the sound from the wind is the only thing that can be heard in the town. In the chill of the evening, there is a bellowing from the rushing wind that rises up through the branches and the trees and the shrubs and the broken rocks. Beyond these trees there is a bright, shiny day and there are bodies. Beyond these trees there is a spark in the air; there is a spark on the tip of every tongue. Beyond these trees there are just more bodies with broken antlers and severed fingers. Beyond these woods there are countless bodies that spill out into the forest and glide out endlessly into the fires of the road. Beyond these trees there are soft voices and light and bodies with scales in the water. Somewhere in the forest branches break. The air swells. Rocks and logs and immovable mountains and rotting chunks of driftwood and broken tree branches and cold lakes and piles of bodies and a soft, silvery wind. If the bodies remain soft and delicate. If the bodies are silent. If there is light shining down on the bodies with wings and scales and broken fingers. If there are voices that cut through the wind. If the west is right now, it hangs in the air above this town. If the west is right now, it is drifting through these soft bodies on the roads. If the west is right now, it is somewhere in the decaying bodies that are sinking into the wet forest floor. The west is made up of flesh; the west is

made up of voices. For a few moments, the stars will light up a pathway that winds through the forest and past the lake and between the mountains. Today, all bodies will disappear into the smoke. Smoke floats through the branches. Memories of fire. Beyond the town there is a clear sheet of water and bald rocks just beneath the surface. Somewhere above the lake there is a tumbling in the air a mile above us. Sometimes bodies wash up on shore. Sometimes bodies break apart. The water in the lakes and the rivers and the streams and the waterfalls. The water in the towns and gutters and ditches. The water on our tongues. Sometimes there is the taste of copper in the air. Bodies in love and darkness. Bodies pressed up against other bodies. Bodies sticky with blood. Bodies intertwining together. On the shore, there are piles of bodies. There are so many voices. There is so much silence. On this shore, there is burning fire and burning flesh. On another quieter shore, there is just the sound of rain falling into the lake. Here, there are glimpses of grey smoke billowing over the tops of trees in the distance. Here, there is a stillness. Here, there is darkness. In the far distance, there is another clear sheet of water, another shore, another islet, another mouth, another body gushing blood in the rain. All the black clouds. All the sheets of rain. In the far distance, there is more smoke, more snow, more wind. Voices can be heard somewhere out there in the storm. For all the bodies along the shore. For all the dark mounds of earth and black rocks and broken branches and intersecting lines of sight from the town. For all the right angles that cut across each other until there is a moment when they intersect. For all the leaves that sprout from wet, black branches. For all the broken rocks and immovable trees and deep, narrow

ravines and soft, dark places. For every walking body. For every black cloud that is pulled apart by rain. For every leaf that springs from the trees. For every broken body. For every mound of flesh. For every limb. For every drop of blood. For every cheek pressed against the mossy trunk of a tree. Beneath the broken clouds is a steep, rugged descent and a trail of bodies spilling down into the town. There are no sounds anymore except for the bodies. There is no town other than this town. There are no bodies other than these bodies. Today, there is no flesh other than this flesh. But in this season, there is just blood and rain and dirt and soft, delicate bodies in the streets. In earlier seasons, snow and ice would cover this shore by the woods overlooking the deep stillness of the lake. The water at the dark bottom of the lake. The blood pools in the streets. Sheets of rain cut through the town. The air is full of water and the taste of salt. Each body softer than the last. Blood gushing from soft, delicate bodies. Blood washing away in the downpour of rain. Blood disappearing into the ditches. Blood and dirt and broken glass and rain. There are bodies that have never left the town. In the town, the bodies will disappear into warm, dark places. Above the town, there is a soft, silvery wind. For a moment, the only light that remains is behind the windows of a few of the houses. For a moment, the light from the town disappears. For a moment, the forest and the town are indistinguishable in the darkness. For a moment, darkness covers over everything until there is a soft orange glow on the horizon, lighting up the forest and trees and the roadways and the town. In the new morning light, the sick and broken bodies on the roadways and in the ditches are lit up again. Beyond the town there is the dark outline of the forest.

There is a light mist in the orange sky. The mist drifts out over the town and between the trees. Between the trees and the broken branches, there are more bodies. If there is space for all these bodies, it is not here in the town but out in the woods and in the shelter of the mountain. If there is space between the towns and the trees and the roads and the shrubs, it is filled with a soft morning light. Somewhere above there is a tumbling in the air a mile above us. Somewhere above there is a soft, silvery wind that disappears into the trees and cuts through the spring air. Some stars can still be seen in the morning through the broken canopy. Somewhere above there is a light from somewhere other than here. There is a bright, delicate light reflected in the river. In the town, there are bodies crusted over with dirt and dried blood. There are bodies heaped with rags and frayed fabric. In the sky above the town, there is the taste of copper. There is blood and dirt and silence. Mist in the pine needles. A soft wind. Cold morning air. There were bodies here in the night. Where there is fire, there are bodies. Where there is smoke, there are bodies. There are slow, intermingling drifts of morning mist that rise up to the sky and disappear in the heat of the sun. Just above the treetops, there is a bright light that cuts through the mist. Just above the expanse. Just above the clouds. Just between the glittering stars, there is an emptiness. Just above the bodies, there are clouds of breath. Just above the treetops, there is the scent of roses and whiskey. Just above the treetops, there is old light from old stars. Just above the treetops, there is an orange, delicate sky and droplets of water hanging in the air. There is a bright light that drifts through the forest and into the town. There are bodies and small fires and there are moments when they seem to intertwine

and exist only together as one. If there is a gust of wind that follows the curvature of the forest and glides down into the town from eighty feet up in the air. If there is the taste of wilderness in the town. If the darkness is just drifting above until the light fades away. If the bruised bodies in the ditches can't quite be seen in the darkness. If the bodies here in this town are forever. If there is a knife pressing at the throat of each body in the town. If the road branches silently into other roads. If there are leaves scattered along the dirt road. If the blood sprays into the air. If there are voices. If there are parallels between the tree branches. If the town breaks open. If a line is drawn. If there are lines connecting the precipices. If the lake sometimes shines in the light from the campfires. If there is ever truly a moment of darkness again. If the bones sink into the mud. If there is the taste of rot in the air. If the smoke consumes the forest and the roadways and the town. If the town is just a point in space. If the south seems like a dream. If the bodies hang in the trees just past the outskirts. If the broken lines come together again at the centre of town. If the woods disappear into the rain. If the woods disappear into the town. If there is old light and rain and black rocks. If there are caverns in the rocks that lead us into darkness. If there is the promise of warmth unfolding in the spring. If there are broken sheets of rain cutting through the town. If there is sickness. If there is fear. If the blood runs like a river in the rain. If flesh is peeled from the bone. If slow, intermingling drifts of sounds and scents float through the air. If the moon reflects the light from the sun. If there are bodies and towns and broken land and hunger and fire and windows that look out onto the crushed rocks in the road. If there is a country. If there is a nation. If there is

a howling wind in the passageways between the broken rocks.
If some other, softer place is not softer at all. If some other, softer
place is always just down the road. If blood gushes from every
body. If the darkness never lifts. If there is a tumbling in the air
above us. If the bodies are drained of blood. If the flesh becomes
still. If there are steep pathways between the rocks that lead up the
mountain. If there are bodies on those roadways. Bodies in the
darkness. Bodies seen through the sheets of rain. Bodies within
bodies in the coolness of the night. Bodies in love entangled with
darkness. In the spring, the mud will soften. The bones will sink
into the black earth. Some flesh remembers. Some flesh disappears
into the mud. Some flesh carries the lingering scent of roses. Some
waters dry up. Somewhere there are bodies digging out the side of
the mountain. Somewhere in the warm spring rain bodies are
wiping the water away from their eyes. Somewhere in the town
there are voices crying out. There will always be a line running
between the towns. Crushed rocks and pathways of hard dirt and
broken bodies in the ditches. There will always be voices. There
will always be words. There will always be some idea of a country.
There will always be a future. There will always be a roadway.
Tomorrow might arrive in the town across the water. Tomorrow
blossoms in every town. Tomorrow, there will be more voices, more
bodies, more flesh, more roadways. Tomorrow is a circle. Tomorrow
is a line that cuts endlessly along the horizon. Tomorrow is a
recurring dream. In the river, there is blood. In the town, there is
a stream of blood that runs down the gutter along the road. There
are broken bodies and broken bones. In the town, there is an open
square and a pile of bodies. To see the skulls in the road. To sift for

gold. To extract the claws. To puncture the hide. To see the line that connects the bodies to the road to the wing to the fingers to the antlers. Tonight, the stars will puncture the darkness, but it is not yet night and the black clouds just drift through the sky. Bones will break. Ears will turn black and eventually fall off. Toes will rot. Fingers will curl. There is a falling sheet of rain from somewhere above in the black clouds. There are clouds of breath. There is laughter and lamplight. There is light from the windows. There are dark, grey clouds. There is heavy air and heavy rain. The sun is somewhere beyond the black clouds, but it is the light from the town that cuts through the rainy, dark afternoon.

# VI

The sun is somewhere beyond the black clouds, but it is the light from the town that cuts through the rainy, dark afternoon. There are voices and there is firelight. There are falling sheets of rain from somewhere above in the black clouds. In this town, fingers will curl, toes will rot, claws will be severed. In this town, ears will turn black and eventually fall off. Antlers will break. Scars will thicken on the backs of hands. The stars will puncture the darkness. Light from the stars will break through the black clouds. A line connects the bodies to the road to the river to the clouds. A line connects the stars to the skin. A line connects the heart to the toes to the wings. To sift for gold. To see the skulls in the ditch. To see the open square and the pile of bones in the sharp summer light. To see the broken bodies and the broken bones. To see the waves of heat. To see the blood in the gutter. The blood in the river. Tomorrow is a recurring dream. Tomorrow is a line that cuts endlessly through the town. Tomorrow blossoms in every moment. Tomorrow might arrive in the next few minutes. There will always be a line in the dirt. There will always be some idea of a country. There will always be crushed rocks and straight pathways of hard dirt and broken bodies in the ditches. There will always be straight lines between the towns. Somewhere in the town there are voices crying out. Somewhere in the summer wind bodies are wiping the sweat away from their eyes.

Somewhere there are bodies hollowing out the earth from under the road. Some mountain waters disappear into the earth. Some waters dry up. Some flesh carries the lingering scent of roses. Some flesh disappears into the summer heat. Some flesh remembers the contours of the town. Some flesh will sink into the black earth beneath the town. In the summer, the bones will be bleached by the sun. In the summer, there are bodies within bodies in the sticky heat of the night. Bodies entangled in waves of heat. Bodies in the darkness. If there are bodies on the roadways. If there are stretches of crushed stones between the houses. If the flesh rots in the heat. If the bodies are drained of blood. If some other, softer place is not softer at all. If there is a howling wind between the cracks in the bricks. If there are bodies and towns and broken land and hunger and fire and windows that look out onto the road. If flesh is peeled from the bone. If the blood runs like a river through the streets. If there are broken sheets of warm rain cutting through the summer night.
If there are yellow lights from the town and warm rain and black rocks. If the town has disappeared into the rain. If the broken line comes together again. If the south seems like a dream. If there is the taste of blood in the air. If the bones sink into the mud in the summer rain. If there are lines connecting the tips of buildings. If a line is drawn in the mud. If the town. If the connecting lines. If the tree branches. If there are voices. If the blood sprays into the air. If there are leaves in the streets. If the road diverges into other roads. If there is a knife pressing at the throat of each body in the town. If there is the taste of smoke in the town. If there is a strong gust of wind that follows the curvature of the ditches and glides through the town at ninety miles an hour. At this height, about a quarter

mile from the edge of the town, the sun burns the tops of buildings. The shining sky is just a little closer. There are bodies and there are small fires and there are moments when they seem to intertwine and exist only together as one. There are bodies that walk along the streets. There is a bright light that drifts down the street and out of the town. Just above the rooftops, there is water hanging in the air. Just above the rooftops, there is an orange, delicate sky. Just above the rooftops, there is the old light from old stars piercing the morning. Just between the glittering stars, there is an emptiness. Just above the clouds. Just above the expanse. Just above the rooftops, there is a bright light that cuts into the town. There are slow, intermingling drifts of morning mist that rise up to the rooftops and disappear in the heat of the sun. Where there is smoke, there are bodies. Where there is fire, there are bodies. A warm summer breeze drifts through the streets and up through the town. A soft wind cuts between the bodies. A cloud of mist just beyond the rooftops. Brown pine needles in the gutter. The water collecting on the roof looks as though it's just about to break. Concentric circles rippling outward in the puddles. Somewhere deep underneath these streets. Somewhere in the dark earth. Some other voice. Some old patch of black earth from somewhere other than here. Some mountain. Some stream. Some overflowing ditch. Some body. Some breath. Some crooked wilderness. Some other town. Sometimes there is no way to tell where the scent of roses is coming from. There is blood and stone and silence. There are bodies heaped with rags and frayed fabric. In the town, there are bodies crusted over with dirt and dried blood. There is a bright, delicate light reflected in the pools of water at the edges of the streets. Somewhere above there is a light

from somewhere other than here. Some stars can still be seen in the morning above the rooftops and through the dirty windows. Somewhere above there is a soft, silvery wind that disappears into the trees and cuts through the summer air. Somewhere above there is a tumbling in the air a mile above us. If there are spaces between the towns, they are filled with a soft morning light. If there is space for all these bodies, it is here in the town and on these streets. Between the trees and the broken branches, there are more broken bodies. The mist drifts out over the town and between the trees outside. Beyond the edges of the town there is the dark outline of the forest. In the new morning light, the sick and broken bodies on the streets and in the ditches are visible. Cold dew has formed on this flesh. At this very moment, there is a soft orange glow on the horizon, lighting up the forest and trees and the roadways and the town. For a moment, darkness covers everything. The forest and the town are indistinguishable in the darkness. The light from the town disappears. The only light that remains is behind the windows of a few houses. Above the town, there is a soft, silvery wind and an expanding darkness. In the town, the bodies will disappear into warm, dark places. There are bodies that have never left those warm, dark places. Blood and dirt and broken glass and rain. Blood pooling in the streets. Blood gushing from soft, delicate bodies. Each body is softer than the last. Today, the air is full of water and the taste of smoke. There is a cool summer breeze between the buildings in the town. The blood pools in these streets. The water at the dark edge of the buildings. In earlier seasons, rain would cover over this town by the woods overlooking the deep stillness of the forest. But in this season, there is just blood and dirt

and waves of heat and soft, delicate bodies in the streets. Beneath the broken clouds is a steep, rugged descent and a trail of bodies spilling down into the town. For every cheek pressed against the mouldy boards of a house. For every drop of blood. For every limb. For every claw. For every mound of flesh. For every broken body. For every black cloud that is pulled apart by rain. For all the broken rocks and immovable trees and deep, narrow ravines and soft, dark places. For all the wet, black branches. For all the right angles that run parallel to each other. For all the dark mounds of earth and black rocks and broken branches and intersecting lines of sight from the town. For all the bodies in the ditches. Voices can be heard somewhere out there in the summer storm. In the far distance, there is more smoke, more wind. All the waves of heat. All the black clouds. In the far distance, there is another town, another shore, another forest, another mouth, another body gushing blood in the heat, another street, another cluster of windows. There are glimpses of grey smoke billowing over the rooftops in the distance. The heat comes in waves. Waves on waves. In another town, there is laughter and grilled flesh and a cool summer breeze. In another town, there is a raging fire and burning flesh. There is so much silence; there are so many voices. In another town, there are piles of bodies. The bodies intertwining together. The flesh sticky with blood. The flesh pressed up against other flesh. Sometimes there is the taste of copper in the air and the sound of the wind rushing between the buildings. The water in the towns and in the gutters and washing through the ditches and pooling at the edges of the streets; the water in the lakes and the rivers and the streams and the waterfalls. Sometimes there are bodies with broken fingers and claws and soft voices and wings. Sometimes there is a

tumbling in the air a mile above us. Somewhere beyond the town there is a clear sheet of water and bald rocks just beneath the surface. The sun lights up bodies and crooked streets. The heat will arrive in waves. There are just memories of fire. Sweltering heat. Numberless bodies and broken limbs and rotting toes. There is another flame. Smoke billows out of the buildings. If the west is to be made, then bodies will make it. There are bodies in the streets. Bodies with voices that intersect each other and cut through the thick black smoke billowing out of the buildings. Bodies with mouths and fists and knives. If the west is right now, it is drifting between these sharp objects and delicate bodies in the streets. If there is light shining down on the dirt and the streets and bodies. If the street is quiet. If the conversations spill into the night. If the heat boils the blood. Somewhere in the woods there are still rocks and logs and immovable mountains and rotting chunks of driftwood and broken tree branches and cold lakes and piles of bodies and a soft, silvery wind. The air swells. Branches break. Soft voices and light and bodies. Old towns and fire and windows and dirt. Beyond these trees there is a spark in the air. There is a spark on the tip of every tongue. Beyond these trees there is a bright, shiny day. In the heat of the evening, there is a bellowing from the rushing wind that rises up through the branches and the trees and the shrubs and the broken rocks. For a moment, the sound from the wind is the only thing that can be heard in the town. For a moment, the moon is visible. For a moment, the moon is directly above us in the sky. For a moment, the pile of bodies in the ditch is forgotten. In the morning, the bodies will surround the town. In the morning, other bodies will appear. In the morning, there will be other flesh, other voices

in the light that cuts through the dirty windows. There will be bodies between the buildings and the crushed rocks in the street. At some point, the town will break too. At some point, the bodies will break. At some point, the bodies will stop. At some point, the heat will subside. Somewhere in the summer light there is a wave of heat moving through town. All the bodies here are hot and broken. If the roads of crushed rocks sprawl out and intersect together. If the towns are forever. If the intermingling drifts of air above stretch out to intersect with other currents. If the waters here evaporate. If the waters here were just a dream. If the trees. If the rocks. If the soft, silvery wind. If the bodies. If the streets. If the voices. If the west. If the flesh. If the air floats over the lake. If there is scattered light from the clouds above. If there is the taste of copper in the air. If there are piles of bodies being forgotten in the ditch. If there is room for breathing. If there are streets full of fire that run from town to town. If the air floating over the street is full of voices. Mouths move this air. The air that echoes through the streets and between the buildings and out the windows and down past the ditches and out over the stream and into the trees just past the rocks and fissures and mounds of earth and little shrubs and ponds and mossy stumps and broken bones and broken teeth. There are slow waters out there beyond the town. Somewhere deep in the woods there is a dark lake at the bottom of the mountain. Sometimes the fires from the towns die out. Sometimes there are bodies that lose themselves in the town. Sometimes there is white lightning in the sky a mile in the air above us. Sometimes there is the taste of copper in the air. Sometimes the clouds spill out across the sky. Sometimes the bodies are no great distance. Sometimes the

waters rise. Sometimes the elevation plunges. Beyond the forest there are cliffs and forests and rivers and chasms and low bushes and the scent of roses. Beyond the forest there are islands surrounded by other islands. Beyond the forest there are headlands dotted with countless islands. When the light reappears in the morning, there are pink and orange clouds in the sky just above the town. For just a moment, all the soft, dark places of the forest disappear. For just a moment, there is only darkness. For just a moment, there is a sprawling town in a drift of darkness. For a moment, there is only the street. For a moment, there is only the town. For a moment, there is only one body. Only one forest. There are roads and fires and bodies in the ditches. The earth disappears underneath the bodies. The bodies and the road and chasms and the ragged treetops and the black waters and the shores and the horizon and the wet mud and the disappearing trees and the crushed rocks and firelight and the voices and the silence. Beyond the horizon are miles and miles of towns that stretch out to touch each other, that connect to each other with paths of crushed rocks and shallow ditches and lamplight and drifting bodies. There are miles and miles of roadways stretching between the towns. From this spot, the bodies almost seem like part of the road in the afternoon sun. From this spot, this flesh seems to be a part of the earth. From this spot, the sun always seems to be directly above the bodies. After all the heat. After all the air that has been moved from mouth to mouth. After all the hills and the lakes and roads and blood. After all the low strands disappearing into the water and reappearing in parallel. After all roadways winding through the trees. Below the high and broken summits is a clear sheet of water running from

shore to shore. From the tumbling in the air a mile above us. From the blood spilling into the river water. From the soft, dark places of the forest. From the broken branches and the mossy rocks and the deep, narrow ravines. From broken summits and broken sky. From earth. From rain. From starlight. From flame. From the narrow sheets. From the dizzying heights. From the eyes that see themselves. From crushed rocks and crooked roads. From antlers. From claws. From the fingers of the river. From the distant blue hills. From the broken masses of rock. From the bodies and the broken masses of rock and the distant western hills and the spectacle of darkness and the pure exhalations of summer and the eastern shore and the north island and the mountains and silent moments and the shaggy outlines of the tall pines and nearly everything in between. Tonight, coolness spreads through the town. The roadways are lit with fire. Where are the deep shadows in the tall grass? What forms out of the damp morning air? What glory? What anger? The forest stream bends towards the town. Above the trees, the sky is bright and pink and delicate. Bodies will spread out across the expanse of the town and beyond the western horizon as seen through the branches of trees and the west will arrive. Tonight, the streets overflow with bodies. The stars will shine. Numberless bodies and songs and voices. Bodies and air and flesh and moonlight and breath and fire in the towns. In the road, bodies move like fire. In the west, there will be as many bodies as there are leaves on the trees. Some day bodies will break these towns apart. At the edge of the town, there is a narrow, deep river that separates the town from the forest. In the deepest parts of the town, there is another fire. There is breath and silence and fire. Somewhere in the town there are naked bodies and

crying voices and blistering fire. When the town bursts into flames. When white lightning breaks open the sky above us. When the vapours are inhaled. When black smoke drifts through the town like a fog. When the blood is hot. When there is a soft, silvery wind. When the dead can be heard. When the fire burns through the streets. When the spirits can be seen deep in the flame. When the trees outside the town ignite. When the flames can be seen from ninety feet up in the air. Some say there will always be another fire, another town. Some say there will always be another body. Another mouth. Another forest. Another idea. But which other idea? Which other forest? Which other mouth? Which other body? Which other town? Which other endless expanse of roadway? Which position of the dial? Which body with which knife? Some say that all the knives can be counted. Another branch. Another voice. Another tree. Another cluster of bodies. In this steaming gully, there is a darkness that can only be tasted. The open heavens and the drifting vapours and the broken treetops and the roadways and the sullen sounds and crushed rocks and the evening atmosphere and the blazing fire and the deep laughter and the blazing town and the roaring cavern and the rushing water and the impenetrable darkness and the water glimmering in the moonlight and the hills and the gloom and the moving surfaces and the bodies and the quiet uneasiness and the wooded outlines and the silvery wind and the broken branches and soft, dark places in the forest. Behind the curvature of the street, there is a dark outline of a town and a soft, silvery wind. There is a street that cuts through the trees and around the river. Somewhere in the trees there are bodies moving slowly. For a few moments, there is a shaft of moonlight that cuts

through the forest and into the river, illuminating a multitude of shifting whites and blues on the shallow surface. For a moment, the light shines through the tree branches. Which bodies will find each other? Which knives lead to which bodies? Which street will connect which claw with which window? Which town will burn to the ground? The air sinks around the ragged rooftops at the edge of the town. Any flesh moving in the streets. Moving between the buildings. Any flesh moving through the town. Any voice. Any body. Any knife. Any thunder rumbling beyond the distant hills. Any fire. Any breath. Any cool evening breeze sweeping around the bodies. The smoke. The flames. The sparks. The air. The street. The broken teeth. The crushed, broken rocks and the road that winds through the town and across the bridge and into the ragged forest. There are bodies drifting through the summer air, weaving their way through the broken rocks on the road. In the town, the bodies fill up the air with voices and fire and smoke. There is movement; there is breath. Above the rooftops, bodies can be seen drifting back into town. On the edge of the town, there is a river that winds around the broken rocks and sunken, crooked roadways. On the edge of the town, there is a current of water that sinks down beneath the air. The water sinking downstream and under the buildings on the southern outskirts. Somewhere on this river broken branches can be seen floating on the surface of the water. Somewhere under the ragged rooftops is the growing sound of voices. Somewhere under the ragged rooftops there are bodies and there are voices taking up space. At the edge of the town, there is a dead silence and a broken bridge. Every few yards, broken pieces of wood from the bridge appear to float on the surface. For

many moments, the name of the river hangs in the air. For many moments, the name of this town is on the tip of a few tongues. For many moments, the bodies struggle to move across the broken bridge that has fallen into the river. Somewhere there is a name for this type of moment. Some flesh speaks to this particular place at this particular time. Some language is just noise. Some branches sway in the soft, silvery wind. The broken bridge. The flowing river. The heat and the bodies and the low bushes by the ditch. In the distance, there is the sound of thunder. As the air flows up from edges of the town, the sound of soft rain can be heard clearly. From somewhere deep in the town there are more soft bodies, more sharp objects, more breath in the air. From somewhere deep in the town there are voices again. From somewhere at the edge of the town there is the sound of wind whistling through the broken buildings. The cracked beams of wood. The broken stone slabs. The antlers mounted on the walls. The town is nothing more than a series of sounds and scents. There is a gentle, warm wind. Bodies emerge from under broken wood and broken glass. After the floorboards have split apart. After the windows have shattered. After the rooftops have collapsed under the weight of a pool of rain. After the flesh has split open. After the darkness has drifted between the bodies like a wave. After language has failed each and every body. After all the soft places of the town have disappeared. The shadow from the town spreads over the soft expanses of forest. Waves of heat drift though the towns and the rivers and the roadways and the ditches and the mountain lake. The town and the bodies and the street and the gully and the soft, dark places of the forest and the expanding waters and the pools of blood and the shore and the moonlight

and the black clouds and the black roots and the severed limbs and the soft, silvery wind and the rocks between the mounds of earth and the glittering stars and the open air floating over the forest and the valley and the stream and the clear sheets of water and the branching pathways and nearly everything in between. In the town, the blood pools in the street. In the town, there are piles of bodies. There is the scent of rotting fruit that drifts through the street. Somewhere in the velocity of the uproar. Somewhere in the still water. Somewhere in the pools of blood. Somewhere in the pile of bodies. Somewhere in the lamplight. Somewhere in the heat of the summer. Some flames die out. Some flames flicker in the lightest breeze. Somewhere in the darkness above the town there is a soft, silvery wind and black clouds. Somewhere up in the darkness there is the scent of roses and soft water falling from the sky. Some summers last forever. Some heat fills us with hope. Some streets carry us to some other, softer place. Some streets reach out to touch the dead. Some summers seems to last forever. Tomorrow, there will be a bright, warm light from somewhere other than here. Tomorrow, a light will shine down onto the town, onto the pile of bodies. Tomorrow, the pools of blood in the street will reflect the light of the sun directly into the sky above us. A mile above us seems like some other, softer, colder place. A mile in the air above us, there is a tumbling. There are echoes that rush through the street until they disappear. There is a crack of blue lightning and then there is the sound of thunder. There is a stillness here on the edge of the town. There is hard stone and broken branches and a pool of blood and a pile of bodies. There are tall buildings and broken windows and ragged rooftops. There is a soft, silvery wind that drifts

through the town. At this very moment, the warm light from the sun touches the pile of bodies in the streets and there is silence. At this moment, there is a stillness. At another moment, there would be a cool spring rain falling softly over the pile of bodies. At another moment, these streets would be frozen over. At this moment, there is joy and warmth in the air. Today, there is just bright light and a pile of bodies in the streets. Today, there is a light from some other, warmer place. Today, this town is full. At this moment, the heat hangs in the air just above the pile of bodies. At some point, the heat touches the deep, dark centre of the town. Throughout the afternoon, there is a deep silence. There is just the sound of wind whistling through the town. Gliding above somewhere up in the warm summer light is the scent of roses. This town is full of bodies and bones and rocks and trees and broken branches and dead leaves and soft, silvery wind. There are pools of blood that appear throughout the streets. Blood that has been drained from some other, softer bodies. This town is full of flesh that has been cut, claws that have been severed, antlers that have been removed. The streets and the bodies and the warm light and the heat of summer. The sharp reflections visible for just a second in the pools of blood. The vibrant green forest as seen through the windows of the town. There is another heat wave waiting above the ragged treetops. There is a bright summer light cutting through the trees. There are black rocks and shadows and green leaves in the forest. There is a street at the edge of the town where broken bodies clump together. In the short distance between the town and the forest, there is a ditch. In this ditch, there are rotting bodies that clump together and the stench carries up in the air. The street stretches out horizontally

until the edges touch the furthest buildings and the warm light pierces the morning like a sharp knife at the throat. There is warm water in the town and on the shallow parts of the lakes. There are rotting bodies here in the town and in the ditches by the road and in the tall grass and somewhere beneath the floorboards and buried out in the woods. In six hours, the street will stretch out in the warm morning light. In another twelve hours, the street will disappear into darkness for just a few moments. In the town, the bodies are easily forgotten. There is a fierceness on this street. There is a boiling anger in the town square. Bodies and warm light and broken flesh and a grey cloud just covering the sun. Warm light cutting across the stony expanse of the town. Somewhere above the light from the sun turns the clouds red and purple and orange. There are moments when warm light stretches out across the horizon and fills up the streets. A few little houses and shacks and a hitching post and a street that connects up with the town. Mounds of decaying bodies and broken trees sinking into the earth. Slow, intermingling drifts of bodies brushing up against each other during the hot summer nights. Bodies entangled in love and sweat. The open air, where it drifts past the bodies, is full of sounds and scents. This town is full of drunken bodies and sharp knives. The bodies here are ragged with scrapes and bruises and broken fingers and dead eyes. On this flesh, scars will form on top of scars. In this town, the flesh will split open again and again. Below this place, there is a deep hollow in the earth. Above this place, there is a deep hollow in the sky and there is the scent of roses in the air. Above the bodies, there are lights. There are clusters of orange and pink clouds that stretch above the towns. At this very moment, there is a hollow space in

the warm summer sky that is filled with air and clouds and voices. At this very moment, there are countless bodies under the summer sun. In the town, the street sometimes breaks apart again and again until there is barely a path connecting each house, each tavern, each body. There are sometimes great expanses of lights and buildings and pathways and construction and sweaty bodies. In between the streets and the drunken bodies, there are sometimes glittering puddles of brown water that reflect the light of the stars. The streets connect themselves to bodies and lights and taverns and blood. Beyond the town there are hollows and ravines and rushing rivers. Beyond the town there are deep, soft places. Beyond the town there are forests and straits and islets and roads and rocks and other towns. Somewhere there is a street and another street and an unbroken sheet of pavement covering over the surface of the earth. Deep in the forest—among the black rocks and the broken tree branches and the soft, silvery wind and the overflowing rivers and the mounds of black earth and the mossy rocks—there are a few little houses with bright lights and a few soft, delicate bodies. Somewhere in the forest there are glimpses of roses and rocks and shrubs. Somewhere beyond the forest is a town and another town and a street connecting the two together. Somewhere out there is the open, sprawling land; somewhere out there is the open, sprawling town glittering with lights in the summer night. Somewhere there is a street that cuts by the black rocks and the lake. From the street, there is a view of the ragged rooftops and the setting sun. There are towns and bodies and streets and lights from the mountain. There are broken branches and broken bodies and the scent of roses and tree stumps and leaves. Some ninety feet in

the air there is no danger; there are only the broken and the splintered clouds and the view of the open land sprawling with towns and lights and drunken bodies. Sometimes right angles cut right through the forest. Sometimes right angles run parallel to the river. Sometimes ninety feet up in the air there is just light and clouds that turn orange and pink in the setting sun. Somewhere, deep in the town, there is a soft, dark place. Everything here in the town can break apart and come back together again. There are no shapes here other than the buildings. A street with a dozen branching pathways to follow. Under the town, there is a deep hollow. At this very moment, orange and pink clouds spread out across the sky and there's a line that runs straight through the open heavens into some other place. At this very moment, there is an unstoppable wave of heat a mile above us in the air. At this very moment, there are towns that sprawl out across the valley and through the soft, deep place of the forest. At this very moment, there are no other, softer places. On the outskirts of the town, there is a pile of bodies. On the edge of the forest, there are black rocks and hardened roots and mud and tree stumps and broken bones and broken branches and a street leading into the town. At the edge of the town, there is a pile of bodies and a few mossy stones and a pool of blood reflecting the vibrant pink and orange clouds in the sunset.

*Blue Hour*

# VII

At the edge of the town, there is a pile of bodies and a few mossy stones and a pool of blood reflecting the vibrant pink and orange clouds in the sunset. There are black rocks and hardened roots and soft mud and tree stumps and broken bones and leaves that are turning bright orange and a street leading into the town. A pile of bones. At this very moment, there are cities that sprawl out across the valley and throughout the soft forest. There is a cool wind a mile above us in the air. Orange and pink clouds spread out across the sky. Below the city, there is a deep hollow in the earth. A single street divides into a dozen branching pathways. There are no shapes here other than the glass and the buildings and a few trees with leaves falling slowly to the ground. Everything here in the city can break apart and come back together again. Somewhere deep in the city there is a soft, dark place. A hundred feet up in the air, there are clouds that turn orange and pink in the setting sun. Sometimes right angles run parallel to the river. Sometimes right angles cut right through the forest. Sometimes the fall cuts through the city. Sometimes the water is diverted around the city. Some hundred feet in the air there is no danger; there are only the broken and the splintered clouds and the view of the open land sprawling with cities and lights and crumpled metal and drunken bodies. There are broken branches and broken bodies and the scent of roses and

a single tree in the park. There are cities and bodies and streets and lights from the glowing windows. From the street, the sun can be seen setting behind buildings. There is a street that cuts by the black rocks and the lake in the middle of the city. Somewhere out there is the scent of roses. Somewhere out there is another city, another river, another mouth, another street, another set of lights. The soft, silvery wind. The stench of the garbage in the sun. There is the taste of copper in the air. Somewhere out there is the open, sprawling land; somewhere out there is the open, sprawling city glittering with lights in the fall evening. Somewhere beyond the forest is a city and another city and a street connecting the two together. Somewhere in the forest there are glimpses of roses and rocks and shrubs and mountain ranges that disappear just as suddenly as they appear. Deep in the forest—among the black rocks and the broken tree branches and the soft, silvery wind and the chasms and the overflowing rivers and the mounds of black earth and the mossy rocks—there are countless little houses with bright lights and dozens of soft, delicate bodies. Somewhere there is a street and another street and an unbroken sheet of pavement covering over the surface of the earth. Beyond the city there are forests and straits and islets and streets and rocks and other cities and somewhere in the air is the scent of roses. Beyond the city there are deep, soft places. Beyond the city there are hollows and ravines and rushing rivers. The streets connect themselves to other streets, other roads, other pathways, other trails, other cities. The streets connect themselves to bodies and lights and bars and blood. In between the streets and the drunken bodies, there are sometimes glittering puddles of brown water that reflect the light of the stars.

There are sometimes great expanses of lights and buildings and pathways and construction and glassy, concrete towers and sweaty bodies. In the city, there are fractured streets. In the city, the street sometimes breaks apart again and again until there is barely a path connecting each apartment, each bar, each body. In some parts of the city, there are thousands of bodies. Bodies with eyes and bruises. Bodies with claws and wings. At this very moment, there are thousands of bodies on the streets, thousands of bodies under the autumn sun. At this very moment, there is a hollow space below the city. At this very moment, a few of the bodies in the streets are staring up at the sky that is filled with low-hanging pink and orange clouds that drift between the concrete buildings. On this street— the street that intersects endlessly with other streets—there are thousands of bodies. Above the bodies, there are lights. In the ditches between cities, there are crushed rocks and dead bodies and tall grass. Above this place, there is a deep hollow in the sky and there is the scent of roses in the air. Below this place, there is a deep hollow in the earth. In the city, there is firelight and jagged scars on burned bodies and the taste of copper in the air. In this city, the flesh will split open again and again. On this flesh, scars will form on top of scars. In this city, the bodies are ragged with scrapes and bruises and broken fingers and crushed wings. In this city, the bodies cut other bodies. The scent from the intertwining bodies floats up in the air. This city is full of drunken bodies and sharp knives. The open air, where it drifts past the bodies, is full of sounds and scents. Just above the city—just above the rooftops— there is an overlapping space of sounds and scents and colours. In the city, there are spaces for bodies with wings and scales and

antlers. In the city, there are hard, cold places made for bodies. There are slow, intermingling drifts of bodies that brush up against each other during the day. In the forest, there are still black rocks and logs and a river that cuts through the trees. Mounds of old bones and broken trees sinking into the earth. Dozens of little houses and a street that connects up with the town. A dozen voices out in the woods that are lost in the sound of the city. Dozens of inaudible voices coming from somewhere in the forest. There are moments when cool light stretches out across the horizon and fills up the streets. Somewhere above the light from the sun turns the clouds red and purple and orange. There is a warm light cutting across the concrete expanse of the city. There are bodies and cool light and broken flesh and grey clouds just covering the sun. There is a boiling anger here at the centre of the city. There is a fierceness on this street. On the street, these drunken bodies will never be missed. In the city, almost every body is easily forgotten. In the light from the streets, the bodies can appear for a second and then disappear again into the darkness. Every twenty-four hours, the street will disappear into darkness. The street stretches out endlessly from city to city. There are old, buried bones somewhere under the city. There are crushed rocks and garbage and tall grass in the ditches by the road. There is warm water in the city, but the lakes are growing cold. Even the shallowest parts of the lakes are beginning to turn icy. The street stretches out horizontally until the edges touch the furthest buildings and the cool light pierces the morning like a sharp knife at the throat. In this ditch, there are piles of bone that clump together and the sweet smell of fruit wafting up into the air, swept up from the cool breeze of the

afternoon. In the short distance between the city and the forest, there is a ditch. There are broken bones and deep shadows and dead leaves in the ditch. There is a bright light cutting through the trees and into the city. A cool wind rushes between the buildings. The vibrant green forest as seen through the windows of the city. The sharp reflections visible for just a second in the clean blue glass. The streets and the bodies and the cool light and the falling leaves. This city is full of flesh that has been cut, limbs that have been severed, blood that has spilled. There are pools of blood that appear throughout the streets. This city is full of bodies and bones and crushed rocks and trees and broken branches and dead leaves and soft, silvery wind. Gliding above somewhere up in the cool light is the scent of roses. There is the sound of wind whistling between buildings. Throughout the afternoon, there is a deep silence. At some point, the fallen leaves swirl around the deep, dark centre of the city. At this moment, the cool air hangs just above the pile of bones in the ditch. The city is full. There is a light from some other, warmer place. A bright light and a pile of bones in the ditch. A cool breeze. The taste of copper in the air. At another moment, these streets would be sweltering. There would be a cool spring rain falling softly over the pile of bones. At this very moment, the cool light from the sun touches the pile of bones in the streets and in the ditches and there is silence. There is a soft, silvery wind that drifts through the city. There are tall buildings and polished windows and concrete rooftops. There is hard concrete and swirling leaves and a pile of bones. There is a stillness here on the edge of the city. There is a crack of blue lightning and then there is the sound of thunder. There are echoes that rush through

the street until they disappear. A mile in the air above us, there is a tumbling. A mile above us seems like some other, softer, colder place. Tomorrow, the pools of blood in the street will reflect the light of the sun. Tomorrow, a light will shine down onto the city, onto the pile of bones. Tomorrow, there will be a bright, cool light from somewhere other than here. Some seasons seem to last forever. Some streets reach out to touch the dead. Some streets carry us to some other, softer place. Some heat fills us with hope. Some cities last forever. Somewhere up in the darkness there is the scent of roses and soft water falling from the sky. Somewhere in the darkness above the city there is a soft, silvery wind and black clouds. Some flames flicker out in the lightest breeze. Some flames die out. Somewhere in the dying heat. Somewhere in the streetlights. Somewhere in the pile of bones. Somewhere in the still water. Somewhere in the velocity of the uproar. There is the scent of fruit that drifts through the street. The city and the bodies and the street and the gully and the soft, dark places of the forest and the expanding waters and the pools of blood and the shore and the moonlight and the black clouds and the black roots and the severed limbs and the soft, silvery wind and the rocks between the mounds of earth and the glittering stars and the open air floating over the forest and the valley and the stream and concrete towers and the clear sheets of water and the branching pathways and the dead leaves and the streetlights and nearly everything in between. The days stretch out until they disappear. After tomorrow. After the shadows. After the darkness directly in the sky above us. After all the sun and the rain and the waves of heat. After all the soft places of the city. After language has failed each and every body. After the darkness has

drifted between the bodies like a wave. After the flesh has split open. After the rooftops have collapsed under the weight of rain. After the windows have shattered. After the floorboards have split apart. When the bodies emerge from under broken wood and broken glass into the hard expanses of concrete. When the bodies emerge from crumpled metal and glassy towers. When the bodies finally come out into the streetlights at night. When there is a gentle, cool wind. When there is sunlight again in the city. When there is a break in the clouds. When the city is swept up in this sound of rain and thunder and wind. From somewhere deep in the city there are voices again. From somewhere deep in the city there are more soft bodies, more sharp objects, more breath in the air. As the air flows up from edges of the city, the sound of soft rain can be heard clearly. In the distance, there is the sound of thunder. The cool breeze and the bodies and the low bushes by the ditch and the noise of language in the air. The river flowing through the city. The bridge between the two sides of the city. Some trees in the park sway in the soft, silvery wind. Some language is just noise. Some flesh speaks to this particular place at this particular time. Some language has a word for this type of moment. At almost every moment of the day, the bodies move over the bridge that crosses the river. At almost every moment, the name of this city is on the tip of every tongue. For many moments, the name of the river hangs in the air. Every few yards, dead leaves from the trees float along the surface of the river. At the edge of the city, there is a dead silence and a broken street. Somewhere under the concrete rooftops there are bodies and there are voices taking up space. Somewhere under the concrete rooftops is the growing sound of voices. Somewhere on

this river dead leaves can be seen floating on the surface of the water. The water sinking downstream and under the buildings on the southern outskirts. On the edge of the city, there is a current of water that sinks down beneath the air. On the edge of the city, there is a river that winds around the broken rocks and the old, crooked roadways. Above the rooftops, bodies can be seen drifting back into town. There is movement; there is breath. In the city, the bodies fill up the air with voices. There are bodies drifting through the air, weaving their way past each other on the streets. The wind cuts through the city and across the bridge and into the ragged forest. The crooked teeth. The street. The air. The sparks. The flames. The smoke. The bodies with fingers and toes and broken antlers. A cool evening breeze sweeps around the bodies. Any breath. Any fire. Any thunder rumbling beyond the distant hills. Any surface. Any body. Any voice. Any flesh moving through the city. Moving between the buildings. Which bodies will find each other? Which bodies lead each other towards violence? Which voices can be trusted? Which cities have the right bodies? The right voices? Which voice sounds the sweetest? Which connections can be formed from these soft groupings of flesh? Which clusters of flesh will find their way onto the same street at the same time? Which street will stretch on without ending? Which cities will burn to the ground? The air sinks around the concrete rooftops at the edge of the city and the voices sink too. For a moment, the light shines through the glassy towers. For a few moments, there is a shaft of moonlight that cuts through the forest and into the river, illuminating a multitude of shifting whites and blues on the shallow surface. Somewhere in the trees there are bodies moving slowly.

There is a street that cuts through the trees and around the river. Behind the curvature of the street, there is a dark outline of a city and a soft, silvery wind. The open heavens and drifting vapours and broken treetops and sullen sounds and crushed rocks and evening atmosphere and blazing fire and deep laughter and roaring cavern and rushing water and impenetrable darkness and water glimmering in moonlight and hills and gloom and moving surfaces and bodies and quiet uneasiness and wooded outlines and silvery wind and broken branches and soft, dark places in the forest. In this gully, there is a darkness that can only be tasted. Another nation. Another lake. Another gully. Another cluster of bodies. Another fire. Another city. Another tree. Another voice. Another knot. Some say another street cuts through this forest. But which other street? Which other forest? Which other mouth? Which other body? Which other city? Which other country? Which other endless expanse of concrete? Which apartment on which block? Which soft expanse of sky? Which position of the dial? Which direction of the water? Which pause before speech? Some say that all the bodies can be counted. Some say there will always be another fire, another city. Black clouds drift above. The air is full of water. White lightning breaks the sky above us. A part of the city bursts into flames. There are naked bodies and glassy windows and blistering fire. There is breath and silence and fire. In the deepest parts of the city, there is another fire. At the edge of the city, there is a narrow, deep river that separates the city from the forest. Some day bodies will break these cities apart. In the west, there will be as many bodies as there are blades of grass in a park. In the street, bodies move like fire. On the broad side of the street, the air tastes like copper and the city is

full of bodies. Bodies and air and flesh and moonlight and breath and streetlights. Numberless bodies and songs and drunken voices. Tonight, the stars will shine. The streets will be overrun with bodies. The city and the streets and the concrete rooftops and the western horizon as seen through the glassy windows and the west will arrive. Above the concrete rooftops, the sky is bright and pink and delicate. Where are the deep shadows behind the short trees along the edge of the park? What sparks form out of the damp morning air? What country? What street? What moment? The river bends through the city. The streets are lit up at night. The sun sets in a flood. Tonight, coolness spreads through the city. From the bodies and the masses of concrete and the distant western hills and the spectacle of darkness and the pure exhalations of the night and the eastern shore and the mountains and silent moments and the shaggy outlines of the tall pines and nearly everything in between. From the city. From the darkness. From the broken masses of bodies. From the distant hills. From the flesh on the shores. From the southern end. From claw to thigh. From straight, endless streets. From the dizzying heights. From the narrow spaces between buildings. From voice. From paper. From the air pouring across the waste waters that spill out into the river beyond the city. From starlight. From rain. From earth. From broken rooftops and broken sky. From the bodies in the woods and the mossy rocks and the deep, narrow ravines. From the soft, dark places of the forest. From the blood spilling into the river in the park. From the tumbling in the air a mile above us. Below the high, concrete summits is an invisible wave drifting through the city. After all the streets cutting their way through the city. After all the bodies disappearing and

reappearing in parallel. After all the hills and the lakes and streets and concrete towers. After all the air that has held body after body. After all the air that has been moved from mouth to mouth. After all the cities. After all the swirling leaves in the air. The bodies in the cities will find their way into the soft, dark centre. From this spot, the bodies seem to be a part of the earth. There are miles and miles of streets stretching between cities. Miles and miles of cities that stretch out to touch each other, that are connected by streets and shallow ditches and drifting bodies. The bodies and the streets and the chasms and the ragged rooftops and the black waters and the shores and the horizon and the wet mud and the disappearing trees and the crushed rocks and the voices and the silence. For a few moments, the earth disappears under the bodies. There are streets and bones in the ditches. For a few moments, there is just the street. For a few moments, there is no forest, no lake, no bodies, no cities. Only darkness. For just a moment, everything disappears into the soft, dark places of the city. When the light reappears in the morning, there are pink and orange clouds in the sky. Beyond the city there are countless islands. Islands surrounded by other islands. Cliffs and forests and rivers and chasms and low bushes. Sometimes the waters rise. Sometimes the clouds spill out across the sky. Sometimes there is the taste of copper in the air. Sometimes there is white lightning in the sky a mile in the air above us. Sometimes there are bodies lost in the cities. Sometimes there is a fire in the sky. Somewhere deep in the city there is a dark pool of water at the edge of the street. There are slow waters. There is air that echoes through the streets and between the buildings and out the windows and down past the ditches and out over the stream and into the

trees just past the rocks and fissures and mounds of earth and little shrubs. Mouths move this air. If the air floating over the street is full of voices. If there are streets full of light. If there is room for breathing. If there are piles of bone. If the river in the city that cuts through the park is just a dream. If the bodies here are forever. If the streets sprawl out and intersect together. All the bodies here are broken. Somewhere in the evening light there is a cool wind. Bodies between buildings. Light cutting through the windows of the concrete towers. In the morning, other bodies will appear. For a moment, the moon is visible above the concrete rooftops and through the window. For a moment, the sound from the wind is the only thing that can be heard in the town. In the evening, there is the sound from the rushing wind that rises up through the trees and the shrubs and the broken rocks of the forest. Beyond these trees there is a bright, shiny day and there are bodies. There is a spark on the tip of every tongue. Beyond these trees there is a spark in the air. More dirt. More windows. More voices. Somewhere in the city the air swells. What bodies fill the air with language? What country spills out into the air? Somewhere in the city there are paintings of rocks and logs and immovable mountains and rotting chunks of driftwood and broken tree branches and clothed bodies and cold lakes and piles of bone and bright, silvery moons. What ideas grow out of this pile of bones? If the flesh remains soft and delicate. If the street is quiet. If there are streetlights shining down on the dirt and the streets. If there are voices that cut through the night. If the west is right now, then the bodies must appear in the streets at midnight and the flesh must break free. If the west is right now, it hangs in the air above this city. If the west is right now, it is drifting through

these soft bodies lurching in the streets. The west is just bodies. The west is just flesh. Bodies with fists and teeth and claws and eyes. For a few moments, the stars will light up a pathway that winds though the streets and out past the ditches and into another city. All bodies will disappear into the concrete towers. Low-hanging clouds can be seen floating between the buildings. There is another flame. There are numberless bodies and broken claws and rotting toes. Somewhere beyond the city there is a clear sheet of water and bald rocks just beneath the surface. In the houses, there are paintings of the water in the lakes and the rivers and the streams and the waterfalls. There are paintings of the water in the old towns and in the gutters and washing through the ditches and pooling at the edges of the streets. Sometimes bodies are pressed up against each other. Bodies within bodies. Bodies intertwining together. Bodies entangled in sweat and spit. In the ocean, there are waves within waves. The wind swirls dead leaves through the street. Smoke billows over rooftops. Black clouds. Swirling wind. In the far distance, there are dark clouds floating above a far-off city. Voices can be heard somewhere out there in the storm. For all the bodies in the ditches. For all the dark mounds of earth and black rocks and broken branches and intersecting lines of sight from the city. For all the right angles that run parallel to each other until there is a moment when they intersect. For all the wet, black branches. For all the broken rocks and immovable trees and deep, narrow ravines and soft, dark places. For every single body. For every black cloud that is pulled apart by rain. For every cheek pressed against the side of a concrete tower. Beneath the broken clouds is a steep, rugged trail leading down out of the forest. There

are no sounds anymore. In earlier seasons, waves of heat would drift through this place. There are pools of rainwater collecting at the bottom of buildings. Today, there is a cool autumn breeze. Today, the air is full of water and the taste of rotting fruit. Each body is softer than the last. Each body gushing with blood. Blood pooling in the streets. Blood disappearing in the rain. Blood and dirt and broken glass and rain. There are bodies here that have never left the warm, dark places of the city. Above the city, there is a soft, silvery wind and an expanding darkness. For a moment, the only light that remains is shining from the windows of houses. For a moment, the forest and the city are indistinguishable in the darkness. For a moment, nothing can be seen. At this very moment, there is a soft orange glow on the horizon, lighting up the forest and trees and the streets and the city. Cold dew has formed on this flesh in the morning. In the new morning light, the sick and broken bodies on the streets and in the ditches are lit up. For a moment, the flesh is remembered. Beyond the edges of the city there is the dark outline of the forest. There is a light mist in the orange sky. The mist drifts out over the city and between the trees lining the sides of the street. Between the trees and the broken branches, there are more broken bodies. If there is space here for voices, then they are quieter than before. If there is space for all these bodies, it is here in the city and on these streets. If there are spaces between the cities, they are filled with a soft morning light. Somewhere above there is a tumbling in the air a mile above us. Somewhere above there is a soft, silvery wind that disappears into the trees and cuts through the autumn air. Some stars can still be seen in the morning above the rooftops and through the windows. Somewhere above there is a

light from somewhere other than here. There is a bright, delicate light reflected in the pools of water at the edges of the streets. In the city, there are bodies crusted over with dirt and dried blood. There are bodies heaped with rags and frayed fabric. In the sky, there is the taste of blood and concrete and silence. Sometimes there is no way to tell where the scent of roses is coming from. Some clouds in the wind. Some streets. Some other city. Some crooked wilderness. Some overflowing ditch. An old patch of black earth from somewhere other than here. Dark earth somewhere under the streets. Somewhere deep under the city. In the puddles on the streets, concentric circles rippling outward. The water pooling in the ditches. Dead leaves in the gutter. A black cloud just above the rooftops. A soft wind cuts between the bodies. A cool breeze drifts through the streets. Where there is night, there is the cold dew of morning. Where there are knives, there are bodies. Where there is fire, there are bodies. Where there is smoke, there are bodies. There are slow, intermingling drifts of mist that rise up to the rooftops and disappear above the concrete towers. Just above the rooftops, there is a bright light that cuts into the city. Just above the expanse. Just above the clouds. Just between the glittering stars, there is an emptiness. Just above the bodies, there are clouds of breath. Just above the rooftops, there is the scent of roses and whiskey. Just above the rooftops, there is the old light from old stars piercing the morning. Just above the rooftops, there is an orange, delicate sky. Just above the rooftops, there is water hanging in the air. At this height, the shining sky is just a little closer. At this height, about a quarter mile from the edge of the city, the sun burns the tops of buildings. If there is a strong tunnel of wind that follows the

curvature of the ditches and glides through the city at a hundred miles an hour. If the winds are fiercer than before. If the bodies in the city are cleared away. If the thousands of glittering stars above are never quite visible in the light from the afternoon. If the darkness is just drifting above until the light fades away. If there is a knife pressing at the throat of each body in the city. If the street splinters into other streets. If there are dead, swirling leaves. If the blood sprays into the air. If there are voices. If there are trees lining the streets. If there are connecting lines. If a line is drawn in the wet concrete. If there are lines connecting the concrete towers. If there are no more hills or banks or caverns or ravines or steep, rugged ascents. If there is just flesh in the city and on the streets. If the lake in the park sometimes shines in the light from the city. If there is ever truly a moment of darkness again. If the bones sink into the muddy ditches. If there is the taste of blood in the air. If there are moments that lead us away from the centre of the city. If the smoke consumes the forest and the streets and the city. If the city is just a point in space. If the south seems like a dream. If the bodies hang in the trees just past the outskirts. If the broken line comes together again. If the light between the buildings is just moonlight. If the city disappears into the rain. If the woods have disappeared. If there are blue lights from the city and cold rain and black rocks in the park. If there are streets that lead us into more darkness. If there is the promise of a cold winter. If there are broken sheets of rain cutting through the night. If there is sickness. If there is fear. If the blood runs like a river through the streets. If flesh is peeled from the bone. If slow, intermingling drifts of sounds and scents float through the air. If the moon reflects the light from the sun. If there

are bodies and cities and broken land and hunger and fire and windows that look out onto the cracked asphalt of the streets. If there is a country. If there is a nation. If there is a fierce wind pushing through the cracks in the concrete. If some other, softer place is not softer at all. If blood gushes from every body. If the rain never clears. If there is a tumbling in the air above us in the city. If the bodies are drained of blood. If the flesh rots from the inside out. If there are black expanses of streets between the houses. If there are bodies in the streets. Bodies in the darkness. Bodies seen through the swirling leaves in the wind. In the fall, there are bodies within bodies in the cool night. In the fall, the bones will disappear into the ditches. Some flesh will sink into the black earth beneath the city. Some flesh remembers the contours of the city. Some flesh disappears. Some flesh carries the lingering scent of roses. Some waters dry up. Some mountain waters disappear into the earth. Somewhere out there bodies are hollowing out the earth from underneath the street. Somewhere in the wind bodies are wiping the sweat away from their eyes. Somewhere in the city there are voices crying out. There will always be broken bones. There will always be long, straight lines between the cities. There will always be broken bodies and black streets and splintered bones in the ditches. There will always be voices. There will always be words. There will always be some idea of a country. There will always be another day. There will always be a line in the dirt. Tomorrow might arrive in the next few minutes. Tomorrow blossoms in every moment. Tomorrow, there will be bodies entangled in spit and sweat. Tomorrow is a circle. To see the blood in the river that runs through the park. To see the blood that runs down the gutter and

along the street. To see the dead leaves swirling in the wind throughout the city. To see the broken bodies and the broken bones. To see the open square and the pile of bones in the soft autumn light. To see the skulls in the ditch. To see the plated gold. To see the line that connects the claws to the heart to the toes to the street to the city. To see the line that connects the stars to the skin. To see the line that connects the eyes to the knife. Tonight, we will see the line that connects the bodies to the street. Tonight, the light from the stars will break through the black clouds. The stars will puncture the darkness. Scars will thicken on the backs of hands. Bones will break. There are falling sheets of rain from somewhere above in the black clouds. There are clouds of breath in the streets. There are voices and there is blue light from the concrete towers. There is light from the windows. There are dark clouds. There is heavy rain. There is a heavy rain pouring down onto the bodies in the streets. There are black clouds and blue light from the windows and heavy rain and somewhere below the concrete towers there are bodies colliding into each other on the streets.

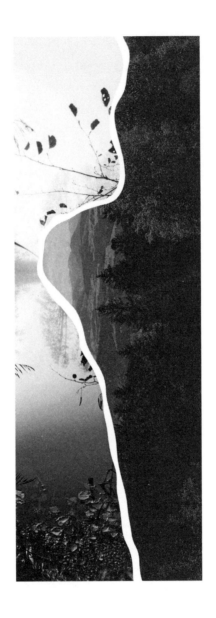

# VIII

There are black clouds and blue light from the windows and heavy rain and somewhere below the concrete towers there are bodies colliding into each other on the streets. There is a heavy rain pouring down onto the bodies in the streets. Heavy rain that slowly turns to ice. Thick grey clouds. Warm light from the windows. There is heavy sleet outside and there are warm, blue lights from the concrete towers. There are clouds of icy breath in the streets. Falling sheets of sleet from somewhere above in the thick grey clouds. In this city, fingers will break, hands will scar. In this city, toes will turn black and eventually fall off. Bones will splinter. Scars will thicken on the backs of hands. Tonight, the stars will puncture the darkness. Tonight, the light from the stars will break through the thick grey clouds. Tonight, we will see the line that connects the bodies to the street. To see the line that connects the eyes to the knife. To see the line that connects the stars to the skin. To see the line that connects the eye to the heart to the knife to the antlers to the wings. To see the plated gold teeth. To see the skulls in the snowy ditch. To see the pile of bones in the heavy sleet. Broken bodies; broken bones. To see the snow swirling in the tunnels of wind between the buildings. To see the ice in the river that runs through the park. Tomorrow is a dream. Tomorrow is a line that cuts endlessly through the city. Tomorrow is a circle. Tomorrow

blossoms in all the entangled bodies. There will always be a line in the snow. There will always be another day. There will always be some idea of a country. There will always be words. There will always be voices. There will always be broken bodies and black streets and splintered bones in the snowy ditches. There will always be long, straight lines between the cities. There will always be broken bones. Somewhere in the city there are voices crying out. Somewhere in the swirling snow bodies are wiping the ice away from their eyes. Somewhere out there bodies are hollowing out the earth from underneath the street. Some frozen waters disappear into the earth. Some waters disappear under the snow. Some flesh carries the lingering scent of roses. Some flesh disappears. Some flesh remembers the contours of the city. Some flesh will disappear into the frozen earth beneath the city. In the winter, the bones will disappear under the snow. In the winter, there are bodies within bodies in the freezing night. Entangled bodies on the soft carpet. Bodies seen through the swirling snow in the wind. Bodies in the darkness. If there are bodies in the freezing streets. If there are endlessly expanding streets underneath the snow. If the flesh freezes from the inside out. If the bodies are drained of blood. If there is a tumbling in the air above us in the city. If the snow never clears. If blood gushes from every body. If some other, softer place is not softer at all. If there is a cold wind whistling through the cracks in the concrete. If there is a nation. If there is a country. If there are bodies and glassy towers in the cities. If there is broken land and hunger and warm fireplaces and windows that look out onto the cracked, snowy asphalt in the streets. If the moon is reflected in the glassy windows of the concrete towers. If slow, intermingling drifts

of snow float through the air between the buildings. If flesh is peeled from the bone beneath fluorescent lights. If the blood pools beneath apartment doors. If there is fear. If there is sickness. If there are broken bodies running through the swirling snow. If there is the distant promise of spring. If there are snowy streets that lead us into more darkness. If there are blue lights from the windows and swirling snow and black rocks in the park and warm, sweaty bodies in the apartment blocks. If the woods have disappeared somewhere under all this snow. If the bodies have disappeared somewhere into all these apartments. If the city is just a series of lights. If the broken line comes together again. If the bodies disappear in the sleet. If snow drifts through the forest and the streets and the city. If there are moments that lead us away from the city. If there is the taste of blood in the air. If the bones in the forest are forgotten. If there is ever truly a moment of silence again. If the icy lake in the park sometimes shines in the light from the city. If there are lines connecting the concrete towers. If a line is drawn in the snow on the sidewalk. If there are lines connecting the apartments to the sidewalk to the wristwatches. If there are barren trees lining the snowy streets. If there are voices. If the blood sprays into the air. If there is swirling, white snow in the streets. If the street turns into another street. If there is the taste of copper in the air. If there is a knife pressing at the throat of each body in the city. If the bodies here in this city are forever. If the bones in the ditches can't quite be seen under the snow. If the darkness is just drifting above until the light fades away. If the thousands of glittering stars above are never quite visible in the sky anymore. If the bodies in the city are cleared away. If there is the taste of smoke in the city. If

there is a tunnel of wind that follows the curvature of the ditches and glides through the city at ninety miles an hour. At this height, about a quarter mile from the edge of the city, the snow drifts over the tops of buildings. There is flesh and there are fluorescent lights and there are moments when they seem to intertwine and exist together as one. There are bodies that trudge slowly through the snowy streets. Just above the city, there is a bright light that shines down on the street and out of the city. Just above the rooftops, there is snow hanging in the air. Just above the rooftops, there is a pink, delicate sky. Just above the rooftops, there is old light from old stars piercing the morning. Just above the bodies, there are clouds of icy breath. Just between the glittering stars, there is an emptiness. Just above the clouds. Just above the expanse. Just above the rooftops, there is a bright light that cuts into the city. There are slow, intermingling drifts of snow that rise up to the rooftops and disappear into the sky above the concrete towers. Where there is smoke, there are bodies. Where there is fire, there are bodies. Where there are knives, there are bodies. Where there is night. Where there is snow. Where there are bodies drifting from apartment to apartment. Snow drifts through the streets and up through the city. A cold wind cuts between the bodies. A grey cloud just above the rooftops. Splintered bones in the frozen earth below the city. Ice in the ditches. Broken bodies in the streets. Somewhere deep under the city. Somewhere deep under the highways. Some other, softer place. Some apartment. Some driveway. Some stretch of highway. Some overheated car. Some overflowing ditch. Some icy breath. Some crooked wilderness. Some foggy windows. Some itchy carpets. Some mad dash between buildings. Somewhere along the

street. Some soft whisper from somewhere other than here. There is blood and snow and concrete. In the sky above. In the sky above the city, there is the taste of copper in the air. In the snow, there are bodies heaped with rags and frayed fabric. In the city, there are bodies crusted over with frozen mud. There is a bright, delicate light reflected in the ice at the edges of the streets. Somewhere above there is a light from somewhere other than here. Some stars can still be seen in the morning above the rooftops and through the windows. Somewhere above there is a soft, silvery wind that disappears between the apartment blocks and cuts above the snowy streets. If there are empty spaces between the cities, they are filled with a soft, swirling snow. If there is space for all these bodies, it is here in the city and in these concrete towers. If there is space here for voices, then they are quieter than before. Between the apartments and the broken asphalt, there are more broken bodies. The snow drifts out over the city and between the trees lining the sides of the street. There are small grey clouds in the orange sky above. At the limits of the city, there is the ragged, snowy outline of the forest. For a moment, the flesh is remembered. In the winter light, the sick and broken bodies on the street are lit up. Ice has formed on this flesh in the morning light. At this very moment, there is a soft orange glow on the horizon, lighting up the concrete towers and the streets and the city and the edge of the forest. Bodies on the snowy street and in the apartment blocks and on the highways and at the limits of the city and on the frozen sidewalks. For a moment, the sun lights up the city. For a moment, nothing can be seen in the blinding light that reflects off the snow and from the windows and off the ice in the streets. For a moment, the light

seems to touch everything. For a moment, the city disappears in the light. Above the city, there is a soft, silvery wind and an expanding light. In the city, the bodies will disappear into warm, carpeted places at night. There are bodies here that have never left the city. Blood and dirt and broken glass and snow. Blood disappearing into the snow. Blood gushing from soft, delicate bodies. Each body softer than the last. Today, the air is full of snow and the taste of rotting fruit. Today, there is a tunnel of winter wind between the buildings in the city. Today, the blood sinks into the snow in the streets. There are little frozen pools of ice at the dark edges of the buildings. In earlier seasons, waves of heat would drift through this city by the woods overlooking the deep stillness of the forest. But in this season, there is just blood and dirt and swirling snow and soft, delicate bodies in the streets. Today, there is no flesh other than this flesh. There are no bodies other than these bodies. There is no city other than this city. Beneath the broken clouds is a steep set of stairs leading down to the city centre. Beneath the broken clouds, there are bodies descending the icy steps. Some cheeks are pressed against warm carpets in the apartment blocks. Some cheeks are freezing in the winds outside. For every drop of blood. For every cheek pressed against the side of a concrete tower. For every finger. For every toe. For every claw and beak and tongue. For every broken body. For every grey cloud that is pulled apart by snow. For all the frozen branches. For all the right angles that run parallel to each other until there is a moment when they intersect. For all the dark mounds of frozen earth and black rocks in the park. For all the broken branches and intersecting lines of sight from the city. For all the bodies in the ditches. Voices can be heard somewhere

out there in the storm. In the far distance, there are dark clouds floating above a far-off city. All the swirling snow. All the black clouds. In the far distance, there is another city, another body gushing blood in the snow, another cluster of windows. Here, there are bodies and swirling snow and warm apartment blocks. There are glimpses of grey smoke billowing over the rooftops in the distance. In another city, there is just the sound of snow swirling in the street. In another city, there are bodies in the streets. In the ocean, there are waves within waves. In the city, there is laughter and grilled flesh and a cold winter wind. In another city, there is a raging fire and burning flesh. Sometimes there is so much noise. Sometimes there are so many voices. There are piles of bodies. Bodies entangled under the snow. Bodies frozen together with blood. Sometimes there is a moment when flesh is pressed up against other flesh. In the apartment blocks, there are paintings of waterfalls and old towns and clothed bodies and empty streets and smoke curling above a forest. In the houses, there are paintings of the water in the lakes and the rivers and the streams and the waterfalls. Sometimes paintings break apart. Somewhere out there above the street there is a tumbling in the air a mile above us. Somewhere out there beyond the city there is a clear sheet of ice and bald rocks just beneath the surface. This morning, there are just memories of fire. Memories of summer. Numberless bodies and broken limbs and crushed wings. This morning, there is another flame. Low-hanging clouds floating between the buildings; bodies drifting through the snow. For a few moments, the stars will light up a pathway that winds though the snowy streets and out past the ditches and into another city. If the west is to be made, then this

flesh will make it. There are bodies that have voices that intersect with each other and cut through the winter night. There are bodies that have voices and fists and blood. The west is just flesh. The west is just bodies with knives. If streetlights shine down on the snow and the bodies. If the street is quiet. What kind of city grows from this old pile of bones? What kind of city gushes with blood? What bodies fill the air with language? What country spills out into the air? What nation cuts through the tall buildings? What old bones can stand this swirling snow? Somewhere in the city there are paintings of rocks and logs and immovable mountains and rotting chunks of driftwood and broken tree branches and naked bodies and cold lakes and piles of bone and bright, silvery moons. Somewhere in the city the air swells and windows break and soft voices spill out into the night. In the evening, there is the sound from the rushing wind that rises up through the trees and the shrubs and the broken rocks in the park. For a moment, the sound from the wind is the only thing that can be heard. For a moment, the moon is visible above the concrete rooftops and through the window. In the morning, bodies will surround the city. Bodies between the buildings and in the street. Bodies in the evening light. If the intermingling drifts of air above stretch out above the city to intersect with other currents of air. If the frozen river in the city that cuts through the park is just a dream. If the trees. If the rocks. If the soft, silvery wind. If the bodies. If the streets. If the air floats over the lake and the city. If there is scattered light from the clouds above. If there is the taste of copper in the air. If there are heaps of bone being forgotten under the snow. If there are streets full of light that run from city to city. If the frozen air floating over the street is full

of voices. If there is a sound that echoes through the streets and between the buildings and out the windows and down past the ditches and out over the frozen stream and into the trees just past the rocks and fissures and mounds of snow and little shrubs and tree stumps and broken bones and broken teeth. There are slow bodies in the city. Somewhere deep under the city there is a chasm and a dark pool of clear water. Somewhere deep under the city there is a rocky chasm that leads down into some other, darker place. Sometimes there is bright blue light in the air. Sometimes the ice rises. At the city limits, there are stretches of asphalt and forests and highways and rivers and cars and chasms and broken bodies and low bushes and the scent of whiskey in the air. At the city limits, there are sometimes stretches of water that lead out to islands that are surrounded by other islands. When the light reappears in the morning, there are pink and orange clouds in the sky just above the city. For just a moment, all the soft, dark places of the city disappear. For just a moment, there is only bright yellow light. Old bones; frozen earth. Snow in the ditches. For a few moments, the earth disappears underneath the snow. Bodies and streets and rooftops and frozen waters and shores and concrete towers and crushed rocks at the side of the highway. Cities stretch out into each other. Miles and miles of streets. From this spot, these bodies seem to be a part of the earth. Cities drift into each other. Cities intertwine. After all the air passing from mouth to mouth. After all the hills and the streets and the lakes in the park and the concrete towers overlooking the trees. There is an invisible wave drifting through the city. Concrete towers. Narrow ravines. Apartment blocks. Snow falls through the broken skylight. Snow

falls onto the stacks of papers. Snow falls into the narrow spaces between tall buildings. There are endless streets between apartment blocks. Between the bodies and masses of concrete and the distant western hills and the spectacle of darkness and the pure exhalations of the night and the eastern shore and the apartment blocks and the mountains and the streets and the shaggy outlines of the tall pines and nearly everything else. A chill spreads through the city. The sky is orange and pink and purple in the sunset. The frozen river bends through the city. Above the concrete rooftops, the sky is bright and pink and delicate. Numberless bodies. Drunken voices. Flakes of snow in the air. Today, the bodies will break this city apart. In the deepest parts of the city, there is another fire. Breath and silence and fire. Naked bodies and glassy windows and blistering fire. When fire runs down the walls around us. When clouds of black smoke drift out of the windows. When the air is full. When bodies turn to ash. When the dead can be heard. When the flames spread from block to block. When there is a soft, silvery wind and snow falling from the sky. When the fire can be seen from miles away. The streets are full of burned and broken bodies. A soft expanse of sky. A tunnel of wind. A frozen current of water. A pause before speech. A pile of flesh at the limits of the city. A view from a concrete rooftop. Some say that all the bodies can be named. Another streetlight. Another drunken voice. Another fire. In this city, there is a darkness that exists only for a second. The open heavens and the drifting vapours and the concrete rooftops and the sullen sounds and the burned bodies and the blazing fire and the deep laughter and the bright lights and the roaring cavern and the rushing waters and the apartment blocks and the impenetrable

darkness and the frozen river glimmering in the moonlight and the streetlights and the stretches of asphalt and the hills and the gloom and the moving surfaces and the bodies and the quiet uneasiness and the wooded outlines and the soft, silvery wind and the broken branches and the soft, dark places of the city and the concrete towers and nearly all the bodies in between. There is a street that curves around the city. There is a dark outline of apartment blocks and concrete towers. There is a tunnel of silvery wind. There is a street that cuts through the trees and around the river. Somewhere in the trees there are bodies clinging to branches. A shaft of moonlight that cuts through the park and into the frozen river. Which light will stretch on without ending? Which cities will burn to the ground? The air sinks around the concrete rooftops at the edge of the city. Any movement in the streets. Any traffic between buildings. Any surface that can hold a body. The wind cuts through the city and across the bridge and into another city. There are bodies falling out of buildings. There are bodies weaving their way past each other on the streets. Bodies in the city that cut each other with knives in the snowy street. Bodies in the city that fill up all the air with the sound of language. Bodies entangled in heat and spit. Above the concrete rooftops, bodies can be seen drifting back into town. At the limits of the city, there is a river that winds around the broken rocks and the old crooked roadways. At the limits of the city, there is a frozen river that sinks down beneath the air. Somewhere on this frozen river burned bodies can be seen on the flat surface of the ice. Somewhere under the concrete rooftops is the growing sound of voices. At the limits of the city, there is a dead silence and heaps of garbage. Every few yards, snow covers over the

piles of dead leaves and garbage and tree branches. For many moments, the name of the river hangs in the air. The name of this city is on the tip of every tongue. Bodies move over the bridge that crosses the frozen river. There is a word for this type of moment. Trees sway in the soft, silvery wind. The bridge stretches between the two sides of the city. The icy river flowing through. The cold winter wind and the bodies and the low bushes by the ditch and the noise of language in the air. In the distance, there is swirling snow. As the air flows up from the limits of the city, the sound of bodies in the streets can clearly be heard. From somewhere deep in the city there are more soft bodies, more sharp objects, more swirling snow in the air. From somewhere deep in the city there are voices again. From somewhere at the limits of the city there is the sound of wind rushing through the broken windows of the apartment blocks. The cracked beams of wood. The broken concrete slabs. The swirling snow and the burned bodies. The city is swept up in the sounds of bodies burning and apartment blocks collapsing and snow falling softly to the streets. At the limits of the city, there is a break in the clouds. At the limits of the city, there is sunlight again. There is swirling snow in a tunnel of wind. There are bodies drifting back into the streetlights. When the bodies emerge from burned apartment blocks and the crumpled metal and the glassy, concrete towers. When the bodies emerge from under broken wood and broken glass and into the hard concrete expanses and soft, swirling snow. After the floorboards have split apart. After the windows have shattered. After the rooftops have collapsed under the weight of snow. After the walls have erupted in flames. After the flesh has split open. After the darkness has drifted between the bodies like a

wave. After language has failed each and every body. After all the soft places of the city have been filled with bodies. After all the swirling snow and freezing winds. After all the darkness directly in the sky above us. After all the shadows have branched into the darkest parts of the night. After tomorrow. After the days have stretched out until they disappear into the night. After all, the sun will be directly above us again. The city and the burned bodies and the street and the gully and the soft, dark places of the apartment blocks and the expanding waters and the pools of blood in the snow and the shore and the moonlight and the black clouds and the black roots and the severed limbs and the soft, silvery wind and the rocks between the mounds of earth and the glittering stars and the open air floating over the forest and the valley and the stream and concrete towers and the clear sheets of ice and the branching pathways and the streetlights and all the bodies in between. In the city, the blood disappears in the snowbanks. In the city, there are piles of old bones and heaps of garbage. There is the scent of rotting fruit that drifts through the street. Somewhere there is a critical velocity in the uproar of the highway. Somewhere there is a winding river of ice, a pool of blood under our seats in the car. An old pile of bones. A streetlight. Somewhere in the dying night. Some flames die out in the cold winds of winter. Some flames flicker out in the lightest breeze. Somewhere in the darkness above the city there is a soft, silvery wind and black clouds. Somewhere up in the darkness there is the scent of roses and soft snow falling from the sky. Some cities last forever. Some cities fill us with hope. Some streets carry us to some other, softer place. Some streets reach out to touch the dead. Some seasons seem to last forever. Tomorrow,

there will be a bright, cool light from somewhere other than here. Tomorrow, a light will shine down onto the city, onto the pile of bones. Tomorrow, the pools of blood will freeze in the streets and the light from the sun will shine directly in the sky above us. A mile above us seems like some other, softer, colder place. Ninety feet in the air above us, there is a tumbling. There are echoes that rush through the snowy streets until they disappear. There is hard concrete and swirling snow and a frozen river and an indescribable stillness. There are tall buildings and polished windows and concrete rooftops. There is a tunnel of wind that whips between buildings. At this very moment, the cold light from the sun touches a group of bodies on the street and there is a moment of silence. At this moment, there are cars on the highway and bodies in the apartment blocks. At another moment. In another minute. At some other, softer time, there would be a cool spring rain falling softly between the buildings at the limits of the city. At another moment, these streets would be sweltering. At another moment, there would be a cool breeze and drops of rain in the air. The city is full. The cold air hanging just above the old pile of bones in the ditch. The snow swirling around the dark centre of the city. Throughout the afternoon, there is silence. The sound of wind blowing through the city. The sound of language in the air. The sound of cars on the highway. The sound of snow swirling through the streets. Gliding above somewhere up in the cold sky, there is the scent of roses. This city is full of bodies and bones and glassy towers and broken branches and frozen rivers and dead leaves under the snow. The streets and the bodies and the cold light and the swirling snow. The sharp reflections that are visible for just a second in the polished

glass. The vibrant, snowy forest as seen through the windows of the city. There is a cold wind drifting between the buildings. There is a bright light cutting through the streets and into the city. There are broken bones and deep shadows and snow in the ditches. There is a ditch at the edge of the city that is full of old, broken bones. In the short distance between cities, there is a ditch full of snow and old, broken bones. At the limits of the city, there are piles of old bones that freeze together in the winter and the sweet smell of fruit wafting up into the air. The street stretches out horizontally like a sharp knife at the throat. Even the deepest parts of the lake have turned to ice. There is still warm water in the apartment blocks, but all the lakes have frozen over. There are stretches of asphalt and garbage and cars on the highway and snow in the ditches by the road. There are old, buried bones somewhere under the city. The street stretches out endlessly from city to city. For just a few moments, there is darkness. Every twenty-four hours or so, the lights will all flicker out at once for just a few moments. In the darkness, all bodies are easily forgotten. In the darkness, there are thousands of bodies and broken bones and soft voices and snow swirling. There is garbage blowing through the streets. There is a cold anger here at the centre of the city. There are bodies and cold light and broken flesh and grey clouds just covering the sun. There is a cold light cutting across the concrete expanse of the city. Somewhere above the light from the sun turns the clouds red and purple and orange. There are moments when cold light stretches out across the horizon and fills up the streets. There are dozens of inaudible voices coming from somewhere on the streets at the limits of the city. A dozen voices somewhere out in the streets that cannot

be heard through the sounds of the city and the swirling snow. Dozens of apartment blocks and a street that runs straight through the city. Somewhere underneath the city there are mounds of old bones and broken, decaying trees sinking into the earth. At the limits of the city, there are still a few black rocks and logs. Slow, intermingling drifts of bodies brushing up against each other. This city is full. Bodies that are ragged with scrapes and bruises and broken wings. On this flesh, scars will form on top of scars. Below this place, there is a deep hollow in the earth; above, there is a deep hollow in the sky. Above the bodies, there are streetlights in the snow. On this street—the street that intersects endlessly with other streets—there are thousands of bodies. At this very moment, a few of the bodies in the streets are staring up at the sky that is filled with low-hanging pink and orange clouds that are drifting between the concrete buildings. At this very moment, there is a hollow space below the city. At this very moment, there are thousands of bodies on the streets, thousands of bodies under the winter sun. In some parts of the city, there are thousands of bodies looking at the snow from behind polished windows. In the city, the street sometimes splits apart, connecting each apartment, each bar, each body. In the city, the streets are fractured. There are sometimes great expanses of streetlights and buildings and pathways and construction and glassy, concrete towers and freezing bodies. In between the streets and the drunken bodies, there are sometimes glittering patches of ice that reflect the light of the stars. The streets connect themselves to bodies and streetlights and bars. The streets connect themselves to other streets, other roads, other cities. Beyond the city there are hollows and ravines and rushing rivers. Beyond the city there are

deep, soft places. Beyond the city there are forests and straits and islets and streets and rocks and other cities and somewhere in the air is the scent of roses. Somewhere there is a street and another street and an unbroken sheet of pavement covering over the surface of the earth. Deep in the snowy forest—among the broken tree branches and the soft, silvery wind and the chasms and the overflowing rivers and the mounds of black earth and the icy rocks—there are countless little houses with bright lights and dozens of soft, delicate bodies. Somewhere in the snowy forest there are glimpses of roses and rocks and shrubs and mountain ranges that disappear just as suddenly as they appear. Somewhere beyond the forest is a city and another city and a street connecting them. Somewhere out there is the open, sprawling land; somewhere out there is the open, sprawling city shining with lights in the winter night. Somewhere in the air there is the taste of copper. Somewhere in the air there is the smell of garbage in the winter sun. The tunnel of silvery wind and glassy, concrete towers and the huddled, broken bodies. Somewhere out there is another city, another river, another mouth, another street, another set of streetlights. Somewhere out there is the scent of roses. Somewhere there is a street that cuts by the black rocks and the lake in the middle of the city. From the street, there is a view of the rooftops and the setting sun. There are views of concrete towers and bodies and streets from the glowing windows. There are broken branches and broken bodies and the scent of roses and a single tree and swirling snow. Some ninety feet in the air there is no danger; there are only the broken and splintered clouds and the view of the open land sprawling with cities and snow and lights and crumpled metal and drunken bodies.

Sometimes the winter cuts right through the city. Sometimes right angles cut right through the bodies in the streets. Sometimes lines run parallel to the concrete towers. Sometimes ninety feet up in the air there is just light and clouds that turn orange and pink in the setting sun. Somewhere deep in the city there is a soft, dark place. Everything here in the city can break apart and come back together again. There are no shapes here other than the glass and the buildings and the apartment blocks and a few barren trees. Below the city, there is a deep hollow in the earth. At this very moment, orange and pink clouds spread out across the sky, connecting the cities below to the open heavens and up to some other, softer place. At this very moment, there is a cool wind a mile above us in the air. At this very moment, there are cities that sprawl out across the valley and throughout the soft forest. At this very moment, there is a soft, dark place in the middle of the city. At the limits of the city, there is an overlapping space of sounds and scents and colours. At the limits of the city, there are bodies with sharp knives and deep scars. At the limits of the city, there is a pile of old bones under the snow and a patch of clear ice in the streets reflecting the orange clouds in the sunset.

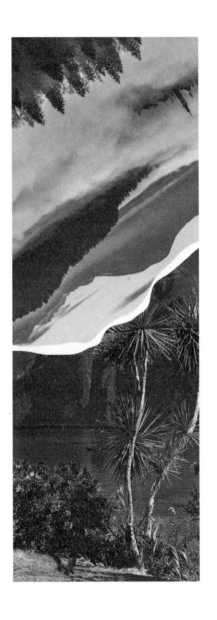

# IX

At the limits of the city, there is a pile of old bones under the snow and a patch of clear ice in the streets reflecting the orange clouds in the sunset. At the city limits, there are cool bodies and deep scars and an overlapping space of sharp objects and soft flesh. At this very moment, there is a soft, dark place at the centre of the city. The city sprawling out across the valley and throughout the soft forest and into the rainy fields. A cool wind a mile above us in the air. Dark clouds spread out across the sky, connecting the cities below to the open heavens and up to some other, softer place. Below the sprawling city, there is a deep hollow in the earth. A single street turns into a dozen streets turns into a hundred streets. Garbage rises out of the melting snow. Everything here in the city can break apart and come back together again. Eighty feet up in the air, there are parallel lines that run between the concrete towers. Sometimes right angles cut right through the bodies in the streets. Sometimes the spring cuts right through the city. Some eighty feet in the air there is no danger; there is only the broken and the splintered and the view of the open land sprawling with cities and rain and lights and crumpled metal and drunken bodies. Somewhere in the air there is the smell of garbage in the spring rain. Deep in the rainy forest—among the broken tree branches and the soft, silvery wind and the overflowing rivers and the mounds of black earth and the mossy rocks—there

are thousands of little houses with bright lights and numberless soft, delicate bodies. Somewhere there is a street and an unbroken sheet of pavement covering over the surface of the earth. Beyond the city there are forests and straits and islets and streets and rocks and other cities and somewhere in the air is the scent of roses. Beyond the city there are deep, mossy places. Beyond the city there are hollows and ravines and rushing rivers. The streets connect themselves to other streets, other roads, other cities, other sets of glowing lights. The streets connect themselves to bodies and garbage and streetlights and bars and rain falling from the sky. In between the streets and the drunken bodies, there are sometimes glittering pools of rain that reflect the streetlights glowing above. There are sometimes great expanses of streetlights and buildings and pathways and construction and glassy, concrete towers and wet, shivering bodies. In the city, the streets are fractured, splintering out into crumbling chunks of old cement. The street splits apart a thousand times, connecting each apartment, each glassy storefront, each bar, each body. In some parts of the city, there are thousands of bodies looking at the rain from behind polished windows. There are thousands of bodies with soft carpets under their feet looking out at the rain and the streetlights and the garbage swirling around the storm drains. At this very moment, there are thousands of bodies on the streets, thousands of bodies shielding their eyes from the rain. At this very moment, there is a hollow space below the city. A few of the bodies are staring up at the low-hanging pink and orange clouds. Above the bodies, there are streetlights in the rain. There are stretches of asphalt and dead bodies in the ditches. There is a deep hollow in the earth. A deep

hollow in the sky. In the city, there are streetlights and jagged scars and the taste of copper in the air. In this city, the flesh will split open again and again. On this flesh, scars will form on top of scars. In this city, the bodies are ragged with scrapes and bruises and broken fingers and torn ligaments. This city is full of neon signs and soft rain. The open air, where it drifts through the neon lights, is full of sounds and scents. Just above the city—just above the rooftops—there is an overlapping space of sounds and scents and blinding colours. In the city, there are warm, soft spaces made for bodies to curl into, spaces for entangled bodies. In the city, there are slow, intermingling drifts of bodies that brush up against each other during the day and into the night. At the city limits, there are blinding lights shining out into the darkness. Somewhere under the city there are mounds of old bones and broken, decaying trees sinking into the earth. At the city limits, there are dozens of apartment blocks and a highway that curves around the city. A dozen voices. A hundred streets. A thousand apartment blocks. Out on the streets, there is melting snow and swirling rain and bright neon lights. There are always voices coming from the streets at the city limits. From somewhere above the light from the sun turns the clouds red and purple and orange. There are bodies and neon lights and broken, cracked flesh and purple clouds in the sunset. There are tired, angry bodies at the centre of the city. There is garbage blowing through the rainy streets. In the darkness, there are thousands of bodies and broken bones and drunken voices and swirling rain in the neon lights. Every twenty-four hours or so, the lights all flicker out at the same time. For just a few moments, there is darkness again. There are stretches of asphalt and garbage and

cars on the highway and neon lights and rainwater pouring into the ditches by the road. Warm water in the apartment blocks; cool rain pouring down outside. The highway stretches out until the edges touch the furthest cities. Piles of old garbage. The sweet smell of rotting fruit. Bright, misty highway. Swirling rain. Old, broken bones in the ditches. There is a ditch that runs between the cities that is full of rainwater and old, broken bones. Bright, misty light at the edge of the highway. Blinding lights cutting through the streets, through the city. There is a tunnel of wind between the buildings. The bright, misty highway as seen through the grimy windows at the city limits. The sharp reflections in the rainwater that are visible for just a second. The streets and the bodies and the neon lights and the swirling rain. This city is full of flesh that has been cut, limbs that have been severed. This city is full. Blood swirling in the rainwater. Blood drained from a few soft, delicate bodies. This city is full of soft, delicate bodies and glassy bones and concrete towers and rivers swirling with garbage and rotting tree branches. Gliding above somewhere up in the spring sky, there is the scent of roses. There is the sound of wind cutting through the city and the sound of language in the air. There is the sound of cars on the highway and bodies moving their mouths. Throughout the night, there is a delicate silence. At some point, the rain swirls around the deep, dark centre of the city. Today, the cool air hangs just above the rainy ditch that stretches out between cities. Today, the streets are full. At another moment, there would be light from some other, warmer place. At another moment, there would be blinding light or a warm breeze or snow blowing through the streets. At some other, softer time. At some other hour. At some

other minute. At some other, softer moment. There are cars on the highway and bodies in the apartment blocks and crumpled metal in the ditches and the sound of rain outside the buildings. A cool light from the sun touches a group of bodies in the streets. There is a soft, silvery wind that drifts through the city. There are tall buildings and polished windows and concrete rooftops and blinding lights. There is hard concrete and swirling rain and garbage flowing down the river. There is a stillness here between the cities. At the outskirts, there is a view of another city. There are spring winds that rush through the rainy streets until they disappear between apartment blocks. A mile in the air above us, there is a tumbling. A mile above us seems like some other, softer, colder place. Tomorrow, the pools of blood are washed away by the rain in the streets and the light from the sun will be obscured by the clouds above us. Tomorrow, a soft light will shine down onto the city, onto the piles of wet bones. Tomorrow, there will be a bright, cool light from somewhere other than here. Some seasons seem to last forever. Some streets reach out to touch the dead. Some streets carry us to some other, softer place. Some cities fill us with hope. Some cities last forever. Somewhere up in the darkness there is the scent of roses and soft rain falling from the sky. Somewhere in the darkness above the city there is a soft, silvery wind and black clouds. Some flames flicker out in the lightest breeze. Some flames die out in the spring rain. Somewhere in the dying night. Somewhere in the streetlights and swirling rain. Somewhere there is a pile of wet bones. Somewhere there is a critical velocity in the uproar of the highway. There is the scent of rotting fruit that drifts through the street. In the city, there are piles of wet bones and heaps of garbage. The burned bodies and the

street and the gully and the soft, dark places of the apartment blocks and the expanding waters and the pools of blood and the shore and the moonlight and the black clouds and the black roots and the severed limbs and the soft, silvery wind and the rocks between the mounds of earth and the glittering stars and the open air floating over the city and the valley and the stream and concrete towers and the clear sheets of water and the branching pathways and the streetlights and all the bodies in between. The sun will be directly above us again. Branching shadows. Swirling wind. Walls erupting in flame. Rooftops collapsing under the weight of rain. Windows shattering from the heat. Floorboards crumbling into red embers. When the bodies emerge from under broken wood and broken glass and apartment blocks and the crumpled metal. The city is nothing more than bodies colliding. As the air flows up from the city limits. As the bodies intersect. As the rain swirls in the air. A warm spring wind and the colliding bodies and the low bushes by the ditch and the noise of language in the air. A river flows through the city and out past the highway. A bridge stretches between highways. There are some trees in the park swaying in the soft, silvery wind. Some language is just noise. Some flesh speaks to this particular place at this particular time. Some words fit this type of moment. The name of this city is on the tip of every tongue. The name of the city hangs in the air. Bodies fill up the air with language. Bodies cut each other with knives in the rainy streets. There are bodies weaving their way past each other. Bodies falling out of buildings. Bodies with scars. Bodies with broken toes. Warm bodies in the cold, rainy street. The wind cuts around the crooked bodies. Fire sweeps around us. Any rain swirling around towers. Any voice. Any

violence. Any sweetness. A shaft of moonlight. A multitude of shifting whites and blues. Drifting vapours. Concrete rooftops. Blinding lights. Impenetrable darkness. The hills and the gloom and the moving surfaces and the bodies and the quiet uneasiness and the wooded outlines and the soft, silvery wind and the broken branches and the soft, dark places of the city and the concrete towers and nearly all the knives in between. Some say that all the bodies have names. A concrete rooftop. A pile of trash at the limits of the city. A stream that runs through the park. A soft expanse of sky above concrete towers. Apartment block after apartment block. But which apartment in which city? On the tip of which tongue? The trees outside erupt in flames. There's a fire burning a row of apartment blocks. The bodies can be heard briefly on the other side of the park. This evening, the flesh will turn to ash. The blood will boil. A black cloud of smoke drifts above the city. The air is full of smoke. Clouds of black smoke drifting out of the windows. Fire running down the walls around us. The city bursting into flames. There is fire and neon lights illuminating the city from eighty feet up in the air. Tonight, there are breathless, drunken voices. A few stars can be seen through the black smoke. Above the concrete rooftops, the sky is black and hollow. Where are the shadows? Where are the bodies at the edge of the park? Where is this country? The river bends around the city and flows underneath certain stretches of highway. Some streets are lit up with a warm orange light, some with cascading neon. Tonight, a chill spreads through the city. From the bodies and masses of concrete and the distant western hills and the spectacle of darkness and the pure exhalations of the night and the apartment blocks and the mountains and the streets and the shaggy outlines of the tall pines

and nearly everything in between. From the broken masses of bodies. From spring. From darkness. From the bodies in the street to the rainy banks of the lake. There are straight, endless streets between apartment blocks. Between the tall buildings, there is a tunnel of wind. Rain falls into the narrow spaces between tall buildings. Rain falls onto the stacks of papers. Rain falls through the broken skylights. From the bodies in the apartment blocks to the bodies sprawled out in the garbage at the edge of the city. From the bodies in the concrete towers to the bodies in the cascading neon lights. From the soft, dark places of the park. From the tumbling in the air eighty feet above us. Below the high concrete summit is an invisible wave drifting through the city. After all the bodies disappear into the cascading neon. After all the hills and the streets and the lakes in the park and the concrete towers overlooking the trees. After all the air that has filled up body after body. After all the air passing from mouth to mouth. After all the blinding city lights. From this spot, the bodies in the city appear to find their way into the soft, dark centre. Appear to break apart in the cool light from the spring sky. Appear to interweave, to drift through each other. The sun seems to be directly above us. These bodies are a part of the city. The streets and the chasms and the rooftops and the cool waters and the shores and the horizon and the concrete towers and the disappearing trees and the crushed rocks at the side of the highway. The city disappears into another city. The old bones are forgotten in the black earth. There are bodies pressed up against the windows. Rain breaks through the skylights. White clouds spill out across the horizon. Sometimes there is bright blue light in the air. Somewhere deep under the city there is a rocky

chasm that leads down into some other, darker place. There are slow bodies in the city. If there is a sound that echoes through the streets and between the buildings and out the windows and down past the ditches and out over the stream and into the trees just past the rocks and fissures and little shrubs and tree stumps and broken bones and broken teeth. If the air floating over the street is full of voices. If there are streets full of light that run from city to city. If there is room for just one more body. If there are piles of bone being forgotten under the earth. If there is scattered light from the clouds above. If the air floats over the towers and through the city. If the flesh. If the west. If the voices in the city are just a dream. If the river evaporates. If the intermingling drifts of air stretch out above the city. All the bodies here are shining in the cascading neon lights. Somewhere in the evening light there is a cold wind that drifts through the city. At some point, the rain will subside. At some point, the bodies will stop moving. At some point, the bodies will break. At some point, the city will break too. For a moment, the pile of bones under the city is forgotten. For a moment, the moon is directly above us in the sky. For a moment, the moon is visible above the concrete rooftops and through the window. For a moment, the sound from the wind is the only thing that can be heard in the city. In the evening, there is the sound from the rushing wind that rises up through the trees and the shrubs and the broken rocks in the park. Beyond these rooftops there is a bright, shiny light and there are bodies. There is a spark on the tip of every tongue. Beyond these cities there are more bodies. Countless bodies that spill out into the streets and glide endlessly into the night. Soft voices and light and bodies and breath. Somewhere in the city

windows break. The air swells. What bodies fill the air with language? What knives cut into this flesh? What bitterness lingers in the streets? Somewhere in the city there are paintings of rocks and logs and immovable mountains and rotting chunks of driftwood and broken tree branches and clothed bodies and cold lakes and piles of bone and bright, silvery moons. If the west is right now, then the bodies must appear in the streets at midnight and the flesh must break free of the blinding neon lights. If the west is right now, it hangs in the air above this city. If the west is right now, it is drifting through these soft bodies in the streets. There are bodies that have voices that intersect with each other and cut through the spring night. For a few moments, the blinding lights of the storefronts will light up a pathway that winds though the rainy streets. Bodies disappearing into concrete towers. Bodies drifting through the rain. Somewhere beyond the city there is a clear sheet of water and glistening garbage just beneath the surface. Somewhere out there above the street there is a tumbling in the air a mile above us. Sometimes forests break apart. In the houses, there are paintings of the water in the lakes and the rivers and the streams and the waterfalls. In the apartment blocks, there are paintings of waterfalls and old towns and clothed bodies and empty streets and smoke curling above a forest. Bodies and blood and knives smashing into each other. Bodies intertwining together in the streets. In another city, there are piles of bodies. There are so many voices, so much noise. The rain swirls through the street. All the black clouds. All the bodies. All the dark mounds of wet earth. For all the right angles that run parallel to each other until there is a moment when they intersect. For all the broken rocks and

concrete towers and immovable trees and stretches of highway and deep, narrow ravines and soft, dark places. For every cheek pressed against the side of a concrete tower. Some cheeks are pressed against warm carpets in the apartment blocks. Some fingers are split open by sharp knives. Beneath the broken clouds, there are bodies down on the streets and in the parks and curled up between concrete towers. Beneath the broken clouds is a steep set of stairs leading down into the centre of the city. Blood and dirt and swirling rain. Heaps of garbage overlooking the highway. The blood disappears into the streets. There is a warm wind between the buildings in the city. The air is full of rain and the taste of rotting fruit. Each body softer and more delicate than the last. Each body gushing blood. There are bodies here that have never left the city. Bodies that only know the warm, carpeted apartment floors. Bodies that buy paintings of rivers. Above the city, there is a soft, silvery wind and an expanding, blinding light. For a moment, the city disappears in the light. For a moment, the light seems to touch everything. For a moment, nothing can be seen in the blinding light that reflects off the rainy streets and the polished windows and the glassy concrete towers. For a moment, every colour can be seen in the blinding light. For a moment, the bodies can exist anywhere. For a moment, the bodies can exist within the light and in the warm apartment blocks and on the highways and at the limits of the city and on the rainy sidewalks. There is time for light and for silence. This is a time to be swallowed whole. At this very moment, there is a soft orange glow on the horizon, lighting up the concrete towers and the streets and the city and the edge of the highway. In the morning light, the sick and broken bodies on the street are illuminated. For a

moment, the flesh is remembered. At the limits of the city, there is the ragged outline of the garbage lining the edges of the highway. There are small grey clouds in the orange sky above. The rain drifts out over the city and between the trees lining the sides of the street. Between the apartments and the broken asphalt, there are more broken bodies. If there is space here for voices, then they are quieter than before. If there is space for all these bodies, it is here in the light and in these concrete towers. If there are spaces between the cities, they are filled with a soft, swirling rain. Somewhere above there is a tumbling in the air a mile above us. Somewhere above there is a soft, silvery wind that disappears between the apartment blocks and cuts above the rainy streets. Some stars can still be seen in the morning above the rooftops and through the windows. Somewhere above there is a light from somewhere other than here. There is a bright, delicate light reflected in the brown water at the edges of the streets. In the city, there are bodies crusted over with mud and dried blood. In the rain, there are bodies heaped with rags and frayed fabric. In the sky above, there is blood and rain and concrete and blinding light. Sometimes there is no way to tell where the scent of garbage is coming from. Sometimes the wind cuts between the apartment blocks. Some forgotten old roadways beneath the highway. Some forgotten old bones beneath the city. Some light. Some bodies. Some distant place. Some grey clouds in the sky above the city. Some soft whisper from somewhere other than here. Somewhere along the street. Some mad dash between buildings. Some itchy carpets. Some foggy windows. Some dry heat. Some crooked wilderness. Some warm breath. Some overflowing ditch. Some overheated car. Some stretch of highway. Some driveway.

Some apartment. Some place from somewhere other than here. Some other, softer place. Some old, broken wood. Some other voice. Somewhere in the dark earth. Somewhere deep underneath the highways. Somewhere deep under the city. Broken bodies. Rain in the ditches. Splintered bones in the earth below the city. A grey cloud just above the rooftops. A warm wind cuts between the bodies. Rain drifts through the streets and through the city. Bodies drift from apartment to apartment. Bodies with knives. Bodies with claws. Where there are bodies, there is fire. Where there is smoke, there are bodies. There are slow, intermingling drifts of rain that disappear into the sky above the concrete towers. Just above the rooftops, there is a bright light that cuts into the city. Just above the expanse. Just above the clouds. Just between the glittering stars there is an emptiness. Just above the bodies, there are clouds of breath. Just above the rooftops, there is the scent of roses and whiskey. Just above the rooftops, there is old light from old stars piercing the morning. Just above the rooftops, there is a pink, delicate sky. Just above the rooftops, there is rain hanging in the air. Just above the city, there is a bright light that shines down on the street and out of the city. There are bodies that drift through the rainy streets. There is flesh and there are fluorescent lights from the concrete towers and there are moments when they seem to intertwine and exist together as one. At this height, the sky is just a little closer. At this height, about a quarter mile from the edge of the city. At this height, at the edge of the tower roof. If there is a tunnel of wind. If there is the taste of smoke in the air. If the bodies in the city are swallowed up. If the thousands of glittering stars above are never quite visible in the sky anymore. If the darkness is just

drifting above until the light fades away. If the bones in the ditches can't quite be seen under the heaps of garbage. If the bodies here in this city are forever. If there is a knife pressed at the throat of each body in the city. If there is the taste of copper in the air. If the street turns into another street. If there is swirling rain in the streets. If the blood sprays into the air. If there are voices. If there are trees lining the streets. If there are lines connecting the apartments to the sidewalk to the light above. If there is a city. If a line is drawn in the wet cement. If there are lines connecting the concrete towers. If there is just flesh in the city and on the streets. If the lake in the park sometimes shines in the light from the city. If there is ever truly a moment of silence again. If the bones in the forest are forgotten. If there is the taste of blood in the air. If there are moments that lead us away from the city. If rain drifts past the highways and the streets and the city. If the city is just a point in space. If the bodies are just a dream. If the bodies disappear into the light. If the broken line comes together again. If the light between buildings guides the bodies through the streets. If the city is just a series of lights. If the bodies have disappeared somewhere into all these apartments. If the bodies are entangled on the soft carpets. If the woods have disappeared somewhere under all these cities. If there are blue lights from the windows and swirling rain and black rocks in the park and warm bodies in the apartment blocks. If there are rainy streets that lead us into darkness. If there is the distant promise of summer. If there are broken bodies running through the swirling rain. If there is sickness. If there is fear. If the blood pools beneath apartment doors. If flesh is peeled from the bone beneath fluorescent lights. If slow, intermingling

drifts of rain float through the air between the buildings. If the moon is reflected in the glassy windows of the concrete towers. If there are broken bodies and hunger and warm fireplaces and windows that look out onto the cracked asphalt in the streets. If there are bodies and glassy towers in the cities. If there is a country. If there is a nation. If there is a warm wind pushing through the cracks in the concrete. If some other, softer place is not softer at all. If blood gushes from every body. If the rain never stops. If there is a tumbling in the air above us in the city. If the bodies are drained of blood. If there are endlessly expanding lights above. If there are bodies in the streets. Bodies in the darkness. Bodies seen through the swirling rain and headlights. In the spring, there are bodies within bodies in the cool night. The bones will disappear into the soft, mossy hollows. Some flesh will disappear into the earth beneath the city. Some flesh remembers the contours of the city. Some flesh carries the lingering scent of roses. Some waters disappear under the highway. Some waters seep into the heaps of garbage at the outskirts of the city. Somewhere in the swirling rain bodies are wiping the water away from their eyes. Somewhere in the city there are broken bones in the streets. There will always be long, fractured lines between the cities. There will always be broken bodies and black streets and splintered bones in the ditches. There will always be bodies with voices. There will always be words. There will always be some idea of a country. There will always be another day. There will always be a line connecting another line. Tomorrow might arrive in the next few minutes. Tomorrow blossoms in all the intertwining bodies. Tomorrow is a crooked line that cuts endlessly through the light. Tomorrow is a dream.

*Antisolar Points*

# X

Tomorrow is a dream. Tomorrow is a jagged line that cuts endlessly through the blinding light. Tomorrow blossoms in all the entangled bodies on the soft carpets. Tomorrow might arrive in the next few seconds. There will always be a line connecting another line. There will always be another day. There will always be some idea of a time before. There will always be words. There will always be bodies with bright lights in their mouths. There will always be broken bodies and black streets and splintered bones in the ditches. There will always be long, crooked lines between the cities. Somewhere in the city there are broken bones in the streets. Somewhere in the sweltering heat, bodies are wiping the light from their eyes. Some light seeps out of the heaps of garbage at the outskirts of the city. Some light disappears under the highway. Some light carries the lingering scent of roses. Some light remembers the contours of the city. Some light will disappear into the earth beneath the city. In the summer, some bodies will disappear into the light. In the summer, there are bodies within bodies in the blinding light. Bodies entangled in heat and sweat. Bodies in the streets and in the lakes and in the higher parts of the sea. If there are endlessly expanding lights below. If the bodies are drained of blood. If there is a tumbling in the air above us in the city. If the heat never lifts. If light gushes from every body. If some other, softer place is not softer at all. If there is a

warm light pulsing through the cracks in the concrete. If there are glassy towers in the light. If there are broken bodies and broken windows that look out onto the blinding streets. If the light is reflected in the glassy windows of the concrete towers. If slow, intermingling drifts of summer heat float through the air between the buildings. If flesh is peeled from the bone beneath the lights. If the light pools beneath apartment doors. If there is fear in the air. If there is sickness. If there are broken bodies running through the streets. If there is the distant promise of winter. If there are blue lights in the windows and sweltering heat and black rocks in the park and warm bodies in the apartment blocks. If the woods have disappeared into all this light. If the bodies have disappeared somewhere into all these apartments. If the city is just a series of lights. If the light between buildings guides the bodies through the streets. If the broken line comes together again. If the bodies disappear into the light. If the bodies are just a dream. If the city is just a point in space. If the clouds drift past the highways and the streets and the city. If there are moments that lead us away from the city. If there is the taste of light in the air. If the forests in the light are forgotten. If there is ever truly a moment of darkness again. If the lake in the park sometimes shines in the light from the hollow sky up above. If there is just flesh in the city and on the streets. If there are lines connecting the concrete towers. If a line is drawn in the wet cement. If there is a city. If there are lines connecting the apartments to the sidewalk to the light above. If there are trees lining the streets. If there are voices. If the blood sprays into the air. If there is light radiating in the streets. If the street turns into another street. If the light turns into more light. If there is a knife

pressed at the throat of each body in the city. If the bodies here in this city are forever. If the bones in the ditches disappear into the light. If the thousands of glittering stars shine through the earth. If the bodies in the city are swallowed up into the light. If there is the taste of light in the air. At this height, at the edge of the tower roof. At this height, about a quarter mile from the edge of the city. At this height, the light is just a little closer. There is flesh and there are pulsing lights from the sky above and there are moments when they seem to intertwine and exist together as one. There are bodies that drift through the light. Just above the city, there is a bright light that shines down onto all these bodies. Just above the rooftops, there is light hanging in the air. Just above the rooftops, there is a pink, delicate sky. Just above the rooftops, there is a dazzling light from some older, softer place. Just above the rooftops, there is the sound of flesh breaking apart. Just above the bodies, there are clouds of hot steam. Just between the glittering stars, there is a sprawling black emptiness. Just above the clouds. Just above the expanse. Just between the empty spaces. There is a bright light that cuts through the city. There are slow, intermingling drifts of light that disappear into the flesh. Where there is light, there are bodies. Where there are bodies, there is light. Bodies exploding with light. Bodies clutching knives. Bodies drifting into the bright street. Light piercing the streets and the city. A warm light cutting between the bodies. A grey cloud just above the rooftops. Splintered bones in splintered light in the earth below the city. Light in the ditches. Light somewhere deep under the city. Light somewhere deep under the highways. Light somewhere in the dark earth. Light from some older, softer place. Some apartment.

Some driveway. Some stretch of highway. Some overheated car. Some ditch. Some warm body. Some crooked wilderness. Some dry heat. Some foggy windows. Some itchy carpets. Some mad dash between buildings. Somewhere along the street. Some soft whispers from some entangled bodies. Some grey clouds in the sky above the city. Sometimes the light cuts between the apartment blocks. Sometimes there is no way to tell where the light is coming from. In the sky above, there is blood spraying into the light. In the sky above the city, there is the taste of blinding light in the air. In the sweltering heat, there are bodies radiating light from their wounds. There are bodies wrapping themselves in bandages, trying to hold in the light. In the city, there are bodies crusted over with the residue of light. Somewhere above there is a light from somewhere other than here. Some stars can still be seen in the morning above the rooftops and through the windows. Somewhere above there is a tunnel of silvery wind that disappears between the apartment blocks and cuts above the streets. Somewhere above there is a tumbling in the air a mile above us. If there is space for all these bodies, it is here in the light. Between the apartments and the broken asphalt, there is more blinding light. The light cuts over the city and between the trees lining the sides of the street. There are small grey clouds in the orange sky above. There is light bursting out of the garbage lining the edges of the highway. In the city, the sick and broken bodies are exploding with light. At this very moment, there is a soft orange glow on the horizon, lighting up the concrete towers and the streets and the city and the edge of the highway. This is a moment when the city is swallowed whole. For a moment, the light can be seen within the bodies. For a moment, the bodies can exist anywhere.

For a moment, every colour can be seen in the blinding light. For a moment, every colour can be seen within the eyes of every body. For a moment, the light seems to touch everything. For a moment, the city disappears in the light. Above the city, there is a soft, silvery wind and an expanding light. In the city, there are bodies staring at paintings of rivers. Bodies that are about to forget the warm, carpeted apartment floors. There are bodies here that are about to forget the city. There are bodies covered in dirt and broken glass and the residue of light. There is light gushing from soft cheeks and scarred fingers. Each body gushing light. Each body softer and more delicate than the last. Today, the air is full of light and the taste of rotting fruit. Today, there is a warm wind between the buildings in the city and there are little pools of light at the dark edges of the buildings. In earlier seasons, rain would drift over the heaps of garbage overlooking the highway. But in this season, there is just light exploding out of bodies and dirt and swirling glass in the warm summer breeze. Today, there is no flesh other than this flesh. There are no bodies other than these bodies. There is no city other than this city. There is no light other than this light. Beneath the broken clouds is a steep set of stairs leading down into the centre of the city. Beneath the broken clouds, there are bodies down on the streets and in the parks and curled up between concrete towers. Curled-up bodies exploding with light. Some cheeks are split open by sharp knives. Some cheeks are pressed against warm carpets in the apartment blocks. Some cheeks are wet with the residue of light. For every cheek pressed against the side of a concrete tower. For every finger. For every toe. For every mound of flesh. For every broken body. For every grey cloud that is pulled apart by wind. For

each body. For all the broken rocks and concrete towers and immovable trees and stretches of highway and deep, narrow ravines and soft, bright places. For all the right angles that run parallel to each other until there is a moment when they intersect. For all the bright mounds of wet earth and black rocks in the park. For all the broken bodies and intersecting lines of light from sky above us. For all the bodies in the ditches radiating light. In the far distance, there are bright clouds floating above a far-off city. In the far distance, there is another city, another shore, another highway, another mouth, another body gushing light in the sweltering summer heat. Bodies and swirling light. Bodies collapsed on the streets. Within the light, there are waves within waves. Within the light, there are bodies and endless voices and soft, bright spaces. Sometimes there is so much light. In another city, there are piles of bodies. The bodies intertwining together in the light. The bodies and knives all smashing into each other. Sometimes there is a moment when flesh is pressed up against other flesh. Sometimes there is the taste of light in the air. Sometimes forests break apart in the light. Somewhere out there above the street there is a tumbling in the air a mile above us. Somewhere out there beyond the city there is a clear sheet of water and glistening garbage just beneath the surface. Today, the light will cut through everything. Today, the bodies with claws will drop to the earth. Today, there are just memories. Numberless bodies with broken wings and briefcases and toes. Low-hanging clouds floating between the buildings. There are bodies drifting through the light. All bodies will disappear. If the west is to be made, then this light will make it. What kind of future can grow out of the light shining from this old pile of bones? What kind of city radiates

light? What future explodes out of these bodies? What old bones can stand this brightness? Somewhere in the city there are paintings of rocks and logs and immovable mountains and wooden bridges and broken tree branches and naked bodies and cold lakes and piles of bone and bright, silvery moons. Somewhere in the city the air constricts. Somewhere in the city windows break. Beyond these cities there are countless bodies that spill out into the streets and glide endlessly into the light. Beyond these rooftops there is a spark in the air. The sound from the tunnel of wind rises through the trees and the shrubs and the broken rocks in the park. For a moment, the sound from the wind is the only thing that can be heard in the city. For a moment, the moon is visible above the concrete rooftops and through the windows. For a moment, the moon is directly above us in the sky. For a moment, the pile of bones under the city explodes with light. In the morning, the bodies will surround the city. In the morning, other bodies covered in the residue of light will appear. There will be bodies between the buildings and in the street. At some point, the light will break the city. At some point, the bodies will break too. At some point, the bodies will stop moving. All the bodies here are bright and shining. If the city is quiet, all the flesh can be forgotten. If the light reaches out and intertwines with the bodies. If the light is forever. If the cities are just for now. If the intermingling drifts of light stretch out above the city to intersect with the currents of air. If the river evaporates in the heat of the light. If the river in the city that cuts through the park is just a dream. If the trees. If the rocks. If the soft, silvery wind. If the bodies. If the streets. If the voices. If the west. If the flesh. If the air floats over the towers and through the city. If there

is scattered light from the clouds above. If there is the taste of light in the air. If there are piles of bone under the earth that are exploding with light. If there are streets full of light. If the air floating over the street is full of bodies suspended in the light. If there is light that beams through the streets and between the buildings and out the windows and down past the ditches and out over the stream and into the trees just past the rocks and fissures and little shrubs and tree stumps and broken bones and broken teeth. There are slow, floating bodies in the city. Somewhere deep under the city there is a chasm and a bright pool of clear light. Somewhere deep under the city there is a rocky chasm that leads down into some other, brighter place. Sometimes there is bright blue light in the air. Sometimes there are bright bodies floating between apartment buildings. Sometimes there are bodies that lose themselves in the light. Sometimes there are burning white clouds seventy feet above us. Sometimes there is the taste of light in the air. Sometimes the burning white clouds spill out across the horizon. Sometimes the floating bodies are no great distance apart. Sometimes the light breaks through the skylights. Sometimes the elevation plunges. At the city limits, there are stretches of asphalt and forests and highways and rivers and cars and chasms and broken bodies exploding with light and the scent of burning clouds in the air. At the city limits, there are sometimes stretches of light that lead out to other cities. Past the city limits, there are stretches of sky that are dotted with countless, floating bodies. For just a moment, all the soft, bright places of the city are visible. For just a moment, there is only the blinding light from some older, softer place. For just a moment, there is a sprawling city in the glowing light. For a

moment, there are only floating bodies in the city. For a moment, there are just floating bodies drifting between concrete towers. For a few moments, the light presses into every soft corner. The old, forgotten bones in the black earth and the bodies exploding with light. There are streets and bones and pools of light in the ditches. For a few moments, the city disappears into another city. The bodies and the streets and chasms and the rooftops and the horizon and the concrete towers and the disappearing trees and the crushed rocks at the side of the highway and heaps of garbage seeping with light. At the city limits, there are miles and miles of other cities that stretch out into each other. At the limits of the west. At the limits of the forest. At the limits of the river. At the limits of the bodies. There are miles and miles of streets stretching between and within cities. From this spot—at the limits of the city—the bodies are part of the light. From this spot, these bodies seem to be a part of the city. From this spot, the sun always seems to be directly above us in the sky. From this spot, the bodies in the city appear to drift into each other. Appear to drift out of each other. Appear to interweave. Appear to break apart in the light. From this spot, the bodies will arrive again and again. From this spot, the floating bodies in the city always appear to find their way into the soft, bright centre. After all the strange light in the sky. After all the air that has been passed from mouth to mouth. After all the air that lingers between bodies. After all the bodies exploding with light. After all the hills and the streets and the lakes of light in the parks and the concrete towers overlooking the trees. After all the bodies disappearing into the cascading neon lights. After all the streets winding their way through the light. Below the high, concrete summits is an invisible

wave of heat drifting through the city. From the tumbling in the air seventy feet above us. From the light spilling into gutters at the edges of the streets. From the soft, bright places of the park. From the bodies in the concrete towers to the bodies in the cascading light. From the bodies in the apartment blocks to the bodies sprawled out in the garbage at the edge of the city. Light pierces the broken skylights. Light fills up the narrow spaces between tall buildings. From the bodies dripping with light. From the bodies collapsed on the concrete. From summer. From the masses of concrete and the distant western hills and the spectacle of sky and the pure exhalations of the day and the eastern shore and the apartment blocks and the mountains and the streets and the shaggy outlines of the tall pines and nearly all the ragged bodies in between. Where are the shadows? Where is the darkness? Where are the cold mornings? A river of light bends around the city and flows underneath certain stretches of highway. Above the concrete rooftops, the sky is blinding and hollow. The city and the streets and the concrete rooftops and the western horizon as seen through the broken glassy windows. Bodies will spread out across the city and drift through the light. Today, the streets will be overrun with bodies. Today, a few glittering stars can be seen beyond the light. Today, there are numberless bodies with light radiating from their eyes. Today, there are breathless, drunken bodies collapsing in the parks. Today, there are burning clouds and neon lights from the bars and a blinding light above from seventy feet up above the surface. Today, the light tastes a little sweeter. Bodies will collide and break apart in the light. In the deepest parts of the city, there are blinding lights and radiant colours and floating bodies intertwining with each other. Naked bodies

dripping with light. A city bursts open around us. Clouds of black smoke drifting out of the windows. The air is full of smoke and light. A black cloud of smoke drifts above the city. Today, the flesh will turn to ash. There's a bright, uncontrollable beam of light burning down a row of apartment blocks. The trees outside erupt in flames. Some say there will always be another cluster of bodies exploding with light. A bright sky above concrete towers. A spinning gear coming to rest. A beam of light. A pile of garbage pulsing with light. All the bodies have names. Some say that all the names can be counted. Drunken bodies spilling their light into the air. Burning clouds. Blazing apartment blocks. Asphalt and hills. Floating bodies. Broken branches. There is a street that curves around the city. There are apartment blocks and concrete towers. There is a soft, silvery wind. There is a street that cuts through the trees and around the river of light. Somewhere in the trees there are bodies moving slowly. Bodies cut apart by the light. For a few moments, there is a shaft of light that cuts through the park and into the bodies, illuminating a multitude of whites and blues and oranges on the shifting surface of their skin. For a moment, the light shines through the glassy towers. Which lights lead towards violence? Which lights can be trusted? Which voice sounds the sweetest in the light? Which light will stretch on without ending? The air sinks around the concrete rooftops at the edge of the city and the floating bodies sink with it. Bodies floating between buildings. A summer day cutting through the flesh. The light cuts through the crooked teeth and the burned bodies and the crumpled fingers. The light cuts through the city and across the bridge and into another city. Fiery bodies in the burning light. Bodies falling out of buildings. Bodies

floating up between the skyscrapers. Bodies spilling light from their eyes and their claws. Bodies floating above the concrete rooftops. Bodies drifting up out of the city. At the city limits, there is a river of light that sinks down beneath the air, a river that winds around the broken rocks and the old crooked roadways. Somewhere in this burning light. Somewhere under the concrete rooftops. Somewhere under the stretches of highway. At the city limits, there are heaps of garbage and blinding lights and broken bodies. Every few yards, there are piles of dead leaves and garbage and tree branches and cascading light coming from every surface. Every few yards, floating bodies collide with each other in the light. For many moments, the name of the light hangs in the air. At almost every moment, the name of the light is on the tip of every tongue. At almost every moment, floating bodies will drift between apartment blocks, across bridges, over highways. Some bodies have a word for this type of moment. Some flesh speaks to this particular place at this particular time in this particular light. Some flesh breaks open in this light. In the park, there are some trees swaying in the soft, silvery wind. A bridge stretches between cities. A river of light flows through the city and out past the highway and into another city. A hot summer wind and the floating bodies and the low bushes by the ditch and the burning light in the air. As the burning light cuts through the air. As the floating bodies collide. As the air flows up from the city limits. From somewhere deep in the city there are more soft bodies, more sharp objects, more radiating light in the air. The radiating light and the burned bodies and the broken concrete slabs and the cracked beams of wood and the pulsing neon and the sound of wind rushing through the broken windows of the

apartment blocks. The city is swept up in the sounds of glass shattering and apartment blocks collapsing and debris falling to the streets. At the city limits, there is pulsing neon shining up into the lights above. At the city limits, there are floating bodies drifting up above the streetlights. When the light emerges from the burned bodies and the ragged apartment blocks and the crumpled metal and the glassy, concrete towers. When the light radiates from under broken wood and broken glass and into the hard concrete expanses and hot, swirling wind. After the light splits apart the floorboards. After the light shatters the windows from the heat. After the rooftops have collapsed. After the walls have erupted in flames. After the flesh has split open. After the light has drifted between the bodies like a wave. After language has failed each and every body. After all the soft places of the city fill with light. After tomorrow. After the days stretch out until they disappear into the light. The sun will be directly above us again. The light will stretch down the street. The city casts no shadows in this light. The city and the burned bodies and the street and the gully and the soft, bright places and the apartment blocks and the overflowing rivers of light and the shore and the moon and the burning clouds and the black roots and the severed limbs and the soft, silvery wind and the rocks between the mounds of earth and the glittering stars and the open air floating over the city and the valley and the concrete towers and the bright sheets of light and the branching pathways and the streetlights and all the broken bodies in between. There is the scent of rotting fruit that drifts through the street. Somewhere there is a critical velocity of light. Somewhere there is a winding river. A pile of bones; a floating body. Some things last forever. Some light fills us with hope. Some light

carries us to some older, softer place. Some light reaches out to touch the dead. Some light seems to last forever. Tomorrow, there will be another light from somewhere other than here. Tomorrow, another softer light will shine down onto the city, onto the piles of broken bodies. Tomorrow, the light will pool under the bodies and the burning clouds will drift up in the air a mile above us. A mile above us seems like some older, softer, quieter place. A mile in the air above us, there is a tumbling. There are summer winds that rush through the bright streets until they disappear between apartment blocks. There is hard concrete and jagged lines of light and garbage in the city. There are skyscrapers and polished windows and concrete rooftops and blinding lights. There is a soft, silvery wind. A warm light from some older, softer place touches a group of bodies in the streets. There are cars on the highway and bodies in the apartment blocks and crumpled metal in the ditches and burning clouds drifting between the buildings. At some other time. At some other minute. At some other hour. At some older, softer time. The floating bodies just hang in the air above the stretches of highway. The light pierces the deep, bright centre of the city. There is the sound of cars colliding into each other on the highway. There are glimpses of crumpled metal and smashed concrete and floating bodies with light pouring out of their mouths. There is light cutting through the city. Gliding up above us in the bright summer sky is the scent of roses. This city is full of soft, delicate bodies and glassy bones and concrete towers and rivers of light swirling with garbage and rotting tree branches and broken glass. There is light being drained from a few soft, delicate bodies. Light burning through the walls. This city is full of light. This city is full. The streets and the bodies and the cascading

lights and the swirling summer wind. Sharp reflections in the glassy windows that are visible for just a second. The bright, misty highway as seen through the grimy windows at the city limits. There is a warm wind drifting between the skyscrapers. There are blinding lights cutting through the streets. There are broken bones and crumpled metal and misty light at the edge of the highway. There is a ditch that runs between the cities that is full of light and old, broken bones. In the short distance between cities, there are stretches of bright, misty highway and swirling wind and old, broken bones in the ditches. At the city limits, there are piles of old garbage and the sweet smell of rotting fruit wafting up into the air that is swept up in the warm breeze of the afternoon. The highway stretches out horizontally until the edges touch the furthest cities, and the warm light pierces the day like a sharp knife at the throat. There are stretches of asphalt and garbage and cars on the highway and neon lights and swirling glass in the wind. There are old, buried bones somewhere under the city. There are old, buried bones exploding with light. The light stretches out endlessly from city to city. From forest to forest. For just a few moments, there is no memory of darkness. Every twenty-four hours or so, the light flickers for just a second. Every twenty-four hours or so, the cities disappear into the light. In the light, all bodies are easily forgotten. In the light, these drunken bodies will never be missed. In the light, there are thousands of bodies and broken bones and drunken voices and swirling wind. There is garbage blowing through the streets. There are tired, broken bodies here at the centre of the city. There are bodies covered with the residue of light, covered in broken, cracked flesh. There are purple and blue clouds in the sunset. There is a

warm light cutting across the concrete expanse of the city. From somewhere above the light from the stars turns the clouds red and purple and orange and pink. There are moments when warm light stretches out across the horizon and fills up the city. Millions of intermingling waves of entangled light. Warm, soft spaces made for bodies to curl into. The floating bodies drift past other floating bodies. Below this place, there is a deep hollow in the earth filling with light; above this place, there is a deep hollow in the bright sky that is filled with thousands of floating bodies. There are thousands of bodies with soft carpets under their feet looking out at the light and the warm summer afternoon and the garbage by the storm drains. In some parts of the city, there are thousands of bodies looking at the light from behind polished windows. In the city, the light sometimes splits apart a thousand times, connecting each apartment, each glassy storefront. In the city, the light splinters out into crumbling chunks of old cement. In between the streets and the drunken bodies, there are sometimes glittering pools of light. The light connects itself to the bodies and the garbage and the bars and the summer rain falling from the sky. The light connects itself to other spectrums, other wavelengths. Beyond the city there are hollows and ravines and rushing rivers of light. There are deep, bright places. There are forests and straits and islets and streets and rocks and other cities and somewhere in the air is the scent of roses. Somewhere there is the light and another light and an unbroken wall of brightness cascading over the surface of the earth. Deep in the forest—among the broken tree branches and the soft, silvery wind and the chasms and the overflowing rivers of light and the mounds of black earth and the mossy rocks—there are thousands

and thousands of little houses within the light and bodies floating up over the canopy. Somewhere in the forest there are glimpses of roses and rocks and shrubs and mountain ranges that disappear just as suddenly as they appear. Somewhere beyond the forest is a city and another city and a street connecting the two together. Somewhere out there is the open, sprawling land; somewhere out there is the open, sprawling light cutting across all the soft surfaces. Somewhere in the air there is the taste of light. Somewhere in the air there is the smell of garbage in the summer heat. The soft, silvery wind and glassy, concrete towers and the huddled, broken bodies. Somewhere out there is another city, another river, another mouth, another street, another blinding light. Somewhere out there is the scent of roses. Somewhere there is a light that cuts through the concrete towers and burns through to the centre of the city. From the street, there is a view of the light above the rooftops. There are concrete towers and floating bodies and streets that can be seen from the glowing windows. There are broken branches and broken bodies and the scent of roses. Some seventy feet in the air there is no danger; there is only the broken, splintered light. Sometimes the summer burns through the city. Sometimes right angles cut right through the bodies in the streets. Sometimes lines run parallel to the concrete towers. Sometimes seventy feet up in the air there is just light and clouds that turn orange and pink in the setting sun. Somewhere, deep in the city, there is a soft, bright place. Everything here in the city can break apart and come back together again. A dozen streets turns into a hundred streets turns into a thousand streets. Below the sprawling city, there is a deep, bright hollow in the earth. At this very moment, burning clouds

spread out across the sky, connecting the cities below to some older, softer place. At this very moment, there is a warm wind a mile above us in the air. At this very moment, there is a soft, bright place at the centre of the city. At the city limits, there is an overlapping space of sounds and scents and colours and burning light.

# XI

At the city limits, there is an overlapping space of sounds and scents and colours and burning light. The light smashing out into the endless highway. A warm wind a mile above us in the air. Burning clouds in the sky. Below the crumbling city, there is a deep, bright hollow in the earth. The broken glass and collapsing concrete buildings and radiating piles of garbage in the streets. Everything here in the city breaks apart and comes back together again in the light. Somewhere deep under the city there is a bright, shining place. Sometimes eighty feet up in the air there is just light and clouds that turn orange and pink in the setting sun. Sometimes bright lines run parallel to the concrete towers. Sometimes shafts of light cut right through the bodies in the streets. Sometimes the light slices right through the city. Some eighty feet in the air there is no danger; there is only the spiralling light and crumpled metal and the drunken bodies filling with light. There are broken branches and broken shafts of light. There are concrete towers and bodies floating through the light between buildings. There is a view from the glowing windows. From the streets, there are sightlines that connect up to the rooftops. Somewhere there is a warm light that cuts through the concrete towers and burns through the centre of the city. Somewhere out there is the scent of flesh burning in the light. Somewhere out there is another river, another city. The soft,

silvery wind and the glassy, concrete towers and the floating bodies in the light. Somewhere in the air is the smell of garbage in the fall breeze. Somewhere in the air is the taste of light. Somewhere the light is cutting across all the soft surfaces. Somewhere in the forest there are glimpses of trees and roses and rocks and shrubs and mountain ranges that disappear just as suddenly as they appear. Somewhere deep in the forest—among the blinding lights cutting through the broken branches—there are thousands of bodies floating up over the canopy. Somewhere there is an unbroken wall of light scraping over the surface of the earth. Within the light, there are forests and straits and islets and streets and rocks and cities and somewhere in the burning air is the scent of roses. Within the light, there are deep, bright places. Within the light, there are mossy hollows and ravines and falling leaves. The light connects itself to other light, other blinding spectrums. The light pierces the bodies and the garbage and the bars and the falling rain from the sky. In between the streets and the drunken bodies, there are sometimes pools of evaporating blood. There are sometimes great expanses of blood and bodies and glassy, concrete towers. Within the light, the city is fractured, splintering out into smouldering chunks of cement and burning copper wire. In the light, the city splits apart a thousand times, prismatic splinters of apartments, glassy storefronts, bodies. In some parts of the light, there are thousands of bodies looking up into some older, softer place. There are thousands of bodies with soft carpets under their feet looking up. There are bodies out in the cool fall afternoon, staring up into the light. Within the light, there are thousands of bodies floating up above the streets. At this very moment, there is a hollow space

below the city exploding with light. At this very moment, a few of the floating bodies in the streets are drifting up into the sky. The sky is filled with low-hanging pink and orange and yellow clouds that are floating between the concrete buildings. Within the light— the light that splinters endlessly into other light—there are millions of floating bodies. In the ditches that stretch out between cities, there are expanses of asphalt and dead bodies and pockets of light and pools of evaporating blood. Below this place, there is a deep hollow in the earth exploding with light; above this place, there is a deep hollow in the blinding sky. In the city, there are streetlights and jagged scars and the taste of copper in the air. In this light, the flesh will split open again and again. On this flesh, scars will form on top of scars. Within this light, the bodies are ragged with scrapes and bruises and crushed wings and torn ligaments. The floating bodies drift past each other. There is the smell of burning flesh. This light is full of drunken bodies and sharp knives and neon signs and burning clouds. The open air, where it drifts through the light, is full of sounds and scents. Just above the city, there is an overlapping space of sounds and scents and blinding colours. In the city, there is flesh and light. There are no more warm, soft spaces made for bodies to curl into. There are no more dark corners in the city. There are no more cities outside the light. In the light, there are millions of intermingling voices. Somewhere underneath the city there are mounds of old bones and broken, decaying trees rippling with light. Millions of floating bodies. Thousands of apartment blocks. The burning light stretches out across the horizon and fills up the city. The light from the stars turns the clouds red and purple and orange and pink. There is a

body floating above the concrete expanse of the city. There are purple and blue clouds in the sunset. Bodies covered with the residue of light. Covered in broken, cracked flesh. Tired, broken bodies. Garbage blowing through the streets. In the light, there are thousands of bodies and broken bones and drunken voices and swirling wind. In the light, these drunken bodies will never be remembered. In the light, all bodies are easily forgotten. Everything disappears into the light for just a moment. Every few days or so, the light flickers out for just a second. For just a second, there is the memory of darkness. The light stretches out endlessly from city to city. There are old, buried bones exploding with light. There are old, buried bones somewhere under the city. There are stretches of asphalt and garbage and cars on the highway and neon lights and swirling glass in the wind. The highway stretches out like a dull blade at the throat. At the city limits, there are piles of old garbage and the sweet smell of rotting fruit wafting up into the air. In the short distance between cities, there are stretches of bright, misty highway and swirling wind and old, broken bones in the ditches. There is a ditch that runs between the cities that is full of evaporating pools of blood and old, broken bones. There are broken bones and crumpled metal and misty light at the edge of the highway. There are blinding lights cutting through the streets. A cool wind between skyscrapers. The bright, misty highway as seen through the grimy windows at the city limits. Broken windows. Streets and bodies. Cascading light. Swirling autumn rain. This city is full. This light is full. This city is full of soft, delicate bodies and glassy bones and concrete towers and rivers of light. Gliding up above us in the bright fall sky is the scent of roses. There is light

cutting through us. There are glimpses of crumpled metal and smashed concrete and floating bodies with light pouring from their mouths. Throughout the day, there is a deep silence, but after a long while, there is the sound of cars colliding into each other on the highway. The light pierces the deep, bright centre of the city. Today, the floating bodies just hang in the air above the stretches of highway that reach out between cities. Today, the streets are full of light. At some older, softer time, there would be old bodies exploding with light and piles of dry bones in the ditches. At some other hour. At some other minute. At some other time. There are cars on the highway and bodies in the apartment blocks and crumpled metal in the ditches and burning clouds drifting between the buildings. A blinding light from some older, softer place touches the bodies in the streets. A tunnel of wind rushes through the blinding streets. A mile in the air above us, there is a tumbling. A mile above us seems like some older, softer, brighter place. The light burns through bodies and through clouds. The light scrapes over the earth. Some light lasts forever. Some light reaches out to touch the dead. Some light carries us, to some older, softer place. Some light fills us with hope. Some things last forever. Some light burns through us. Floating bodies. Light pouring from their eyes. Their mouths. Somewhere there is a pile of bones cracked open by the light. Somewhere there is a pool of light under our seats in the car. Somewhere there is a winding river of light. Somewhere there is a critical velocity. There is the scent of rotting fruit that drifts through the street. In the city, there are piles of dry bones and heaps of garbage radiating light. In the city, the light disappears into the gutters. The city and the burned bodies and the street and

the gully and the soft, bright places and the apartment blocks and the overflowing rivers of light and the shore and the moon and the burning clouds and the black roots and the severed limbs and the soft, silvery wind and the rocks between the mounds of earth and the glittering stars and the open air floating over the city and the valley and the concrete towers and the bright sheets of light and the branching pathways and the blinding caverns and all the floating bodies in between. When the light cuts through the soft expanses of forest. The city casts no shadow. The light stretches endlessly down the street. After the days have disappeared into the light. After tomorrow. After all the soft places of the city have become filled with light. After language has failed each and every body. After the light has pierced each body like an arrow. After the flesh has split open. After the walls have erupted in flames. After the rooftops have collapsed. After the light shatters the windows from the heat. After the light splits apart the floorboards. When the light radiates from under broken wood and broken glass and into the hard concrete expanses and hot, swirling wind. When the light emerges from the burned bodies and the ragged apartment blocks and the crumpled metal and the glassy, concrete towers. Within the light, there are floating bodies drifting up above. Within the light, there are pulsing waves. At the city limits, there are highways that stretch out into other cities, other highways, other clusters of bodies. The city is nothing more than bodies colliding over and over again. The city is swept up in the light. The city is swept up in the sounds of shattering glass and burning chrome. Radiating light and burned bodies and broken concrete slabs and cracked beams of wood and the pulsing waves and the sound of wind rushing

through the broken windows of the apartment blocks and soft bodies and sharp objects and radiating light in the air and floating bodies and low bushes and a river of light and the highway and another city and trees swaying in the soft fall wind and flesh breaking open and soft bodies drifting between apartment blocks and light hanging in the air and bodies colliding with each other in the light and piles of dead leaves and tree branches and cascading light coming from every surface and heaps of garbage and blinding lights and broken bodies and stretches of highway and concrete rooftops and broken rocks and old crooked roadways and the city and bodies spilling light from their eyes in the streets and bodies floating up between the skyscrapers and burning bodies rising between buildings and bodies with scars and bodies with knives and fiery bodies in the burning light and light cutting through the city and light cutting through crooked teeth and crumpled fingers and distant towers and shining surfaces and burning connections forming from these soft groupings of flesh and stretched time and sinking air and concrete rooftops and floating bodies filled with light and glassy towers and a multitude of shifting whites and blues and oranges and bodies cut apart by the light and trees swaying slowly in the wind and the street and apartment blocks and concrete towers and the heavens and drifting vapours and concrete rooftops and sullen sounds and burned bodies and blazing light and apartment blocks and impenetrable brightness and glimmering streetlights and stretches of asphalt and the hills and the moving surfaces of the garbage in the ditches and the floating bodies exploding with light and the quiet uneasiness and the wooded outlines and the soft, silvery wind and the broken branches and the

soft, bright places of the city and the concrete towers and the planets and the countries and the light and the city and the tower and the soft grouping of flesh and the burning clouds and the gathering of drunk bodies and the terrace on a concrete rooftop and a pile of trash and a beam of light and a spinning gear coming to rest and a dial partly turned and a soft, bright expanse of sky above concrete towers and another set of eyes and bodies with feet and antlers and wristwatches exploding within light and the tip of the tongue and another crushed wing and an uncontrollable beam of light burning down a row of apartment blocks and a cloud of black smoke and nearly all the bright things in between. The air is full of smoke and light. Clouds of black smoke pushing up against the windows. Light burning down the walls around us. Light burning down the city around us. Naked bodies dripping with light. Light and silence. In the deepest parts of the planet, there are blinding lights and radiant colours. In the deepest parts of the planet, there are narrow fissures of light that sink down into black chasms. In the deepest parts of the planet, light collides and breaks apart. In the deepest parts of the planet, bodies move like fire. In the deepest parts of the planet, the light tastes a little sweeter. Burning clouds and neon lights from the bars and a blinding light from eighty feet up above the surface and breathless, drunken bodies collapsing in the parks and light radiating from all the eyes and a few glittering stars and the streets and the bodies drifting up into the light and the city and the streets and the concrete rooftops and the expanding horizon and the broken glassy windows and the blinding, hollow sky and the edges of the park and the endless time and river of light and the chasms deep below the surface and the

stretches of highway and the streetlights and the cascading lights and the distant western hills and the pure exhalations and the apartment blocks and the mountains and the streets and the shaggy outlines of the tall pines and the broken masses of bodies and the fall and the crumbling concrete and the burning copper and the bodies dripping with light and the endless streets and the tall buildings and the dizzying heights and the broken skylights and the garbage at the edge of the city and the concrete towers and the light spilling into gutters at the edges of the streets and the tumbling in the air a mile above us and the concrete summits and the hills and the streets and the lakes of light in the parks and the concrete towers overlooking the trees and the bodies exploding with light and the air passing from mouth to mouth and the city lights and the swirling air and the floating bodies and the soft, bright centre of the planet and the bodies that are part of the light now and the miles of streets stretching between cities and edges of the river and the limits of the forest and the highways that stretch out into each other and nearly all the bright, shiny spaces in between. The bodies and the streets and the chasms and the rooftops and the horizon and the concrete towers and the disappearing trees and the crushed rocks at the side of the highway and heaps of garbage seeping with light. For a few moments, the planet disappears into the light. There are bodies and bones and pools of light in the ditches. For a few moments, there are just old, forgotten bones in the black earth and the bodies exploding with light. For a few moments, there is just the light pressing into every soft corner. There is no city. There is no planet. There are no waters or forests or rivers or highways in this blinding light. For a moment, there are just floating bodies

drifting between concrete towers. For a moment, there are only floating bodies drifting away from the surface of the earth. For just a moment, there is only the sparkling light from some older, softer place. For just a moment, all the soft, bright places of the city are visible. Stretches of sky dotted with countless, floating bodies. Stretches of light. Cities enveloped in light. Asphalt and forests and highways and rivers and cars and chasms and broken bodies exploding with light and low bushes and the scent of burning clouds in the air. Sometimes the elevation plunges. Sometimes the light breaks through the skylights. Sometimes the floating bodies are no great distance apart. Sometimes the burning white clouds spill out across the horizon. Sometimes there is the taste of burning copper in the air. Sometimes there are burning orange clouds eighty feet above us in the sky. Sometimes there are bodies that lose themselves in the light. Sometimes there are bright bodies floating between apartment buildings. Sometimes there is bright blue light in the air. Somewhere deep in the planet there is a rocky chasm that leads down into some other, brighter place. Somewhere deep in the planet there is a chasm and a bright pool of clear light. There are bodies slowly floating through the city. The air floating over the street is full of bodies suspended in the light. If there are streets full of light. If there are piles of bone deep in the planet that are exploding with light. If there is the taste of burning copper in the air. If there is scattered fire in the clouds above. If the burning air floats over the towers. If the flesh. If the horizon. If the voices. If the streets. If the bodies. If the soft, silvery wind. If the rocks. If the trees. If the light that cuts through the earth is just a dream. If the bodies disintegrate in the light. If the planet is just for now. If the

light is forever. If the light intertwines with the bodies. If the city is quiet. If all the flesh can be forgotten. If all the bodies here are bright and shining and burning in the light. If, at some point, the bodies will stop moving. If, at some point, the planet will break apart too. If, at some point, the light pulls the crumbling earth apart. If, at some point, there are broken fragments of buildings and streets and apartment blocks drifting over the crust of the earth. If, at some point, everything breaks apart in the light. In the evening air. In another life. In our memories. In the sound of other voices. The light cuts through the windows in the concrete towers and the bodies and the city and the pile of bones underneath and the sky above us. For a moment, the moon is visible above the concrete rooftops and through the windows. For a moment, the sound from the wind is the only thing that can be heard in the city. In the evening, there is the sound from the rushing wind that rises up through the trees and the shrubs and the broken rocks in the park. There is a spark on the tip of every tongue. Somewhere deep in the planet light cuts through the rock. Somewhere deep in the planet the air constricts. What future explodes out of this light? What broken bones hang in the air? Somewhere in the city there are paintings of rocks and logs and immovable mountains and wooden bridges and broken tree branches and naked bodies and cold lakes and piles of bone and bright, silvery moons. If there is a silence in the air up above us. If the horizon is just light. If the horizon spills out across the planet. If the bodies disappear. Bodies drifting through the light. Burning clouds between buildings. A light deep in the earth. Memories of summer. Memories of fire. Somewhere beyond the city there is a clear sheet of water and glistening garbage

just beneath the surface. Somewhere out there above the street there is a tumbling in the air a mile above us. Sometimes forests break apart in the light. Sometimes there is the taste of burning copper in the air. Sometimes there is a moment when flesh is pressed up against other flesh. The bodies and knives all smashing into each other. The bodies intertwining together in the light. In another city, there are piles of bodies. Sometimes there are just so many bodies. Sometimes there is just so much light. Within the light, there are bodies and endless voices and soft, bright spaces. Within the light, there are waves within waves. Bodies and swirling glass. In the city, some cheeks are wet with the residue of light. Curled-up bodies exploding with light. Broken clouds. Burned streets. Splintered limbs. Concrete towers. A steep set of stairs. The centre of the city. The light. The burning clouds. Just light exploding. Swirling glass. A cool fall breeze. Rain. Heaps of garbage. The highway. Little pools of light. The taste of rotting fruit in the air. Soft bodies. Soft cheeks. Scarred fingers. Bodies covered in dirt. Bodies covered in broken glass. The residue of light. The residue of the city. Carpeted apartment floors. Paintings of rivers. A soft, silvery wind. Expanding light. For a moment, every colour can be seen within the eyes of every body. For a moment, every colour can be seen in the blinding light. For a moment, the bodies can exist anywhere. For a moment, the light can be seen within the bodies. There is time for light and for silence. The city is swallowed whole. The planet breaks apart in the light. A soft orange glow. A horizon. Broken chunks of concrete towers swirling through the air. Splintered streets. Smashed highways. Across the surface of the earth, sick and broken bodies are exploding with light. There is

light exploding out of the garbage lining the edges of the highway. There are small grey clouds in the orange sky above. The light cuts over the city and between the trees lining the sides of the street. Between the apartments and the broken asphalt, there is more blinding light. If there is space for all these bodies, it is here in the light. Somewhere above there is a tumbling in the air a mile above us. Somewhere above there is a soft, silvery wind that disappears between the apartment blocks and cuts above the streets. Some stars can still be seen in the morning above the rooftops and through the windows. Somewhere above there is a light from somewhere other than here. There is a bright, delicate light reflected in the brown water at the edges of the streets. In the city, there are bodies crusted over with the residue of light. There are still bodies wrapping themselves in bandages, trying to hold in the light. In the sky above the city, there is the taste of burning copper in the air. In the sky above, there is blood spraying into the light. Sometimes there is no way to tell where the light ends. Bodies rupturing with light. Light shining from their eyes. Slow, intermingling drifts of light that penetrate the skin. There are bodies that drift through the light. There is flesh and there are waves of light from the sky above and there are moments when they seem to intertwine and exist together as one. If there is a knife pressed at the throat. If the light burns through the earth. If the street turns into another street. If the blood sprays into the air and evaporates in the burning light. If the burning clouds drift past the highways and the streets and the city. If the city is just a point in space. If the bodies are just a dream. If the bodies disappear into the light. If the broken line comes together again. If the earth can

just be forgotten. If the city is just light. If the bodies are just light. If there is the distant promise of spring. If the light pools beneath apartment doors. If flesh is peeled from the bone beneath the lights. If slow, intermingling drifts of bodies float through the air between the swirling chunks of broken concrete and smashed glass. If the bodies can just be forgotten. If the concrete towers can just be forgotten. If some other, softer place is not softer at all. If light gushes from every body. If the light never lifts. If there is a tumbling in the air above us. If the bodies are drained of blood. If there are endlessly expanding lights below and above. Bodies exploding with light in the streets and in the lakes and in the higher parts of the sea. Bodies within bodies within bodies in the burning light.

The earth disappearing into the light. Some light remembers the contours of the earth. Some light carries the lingering scent of roses. Some light disappears under the highway. Some light seeps out of the heaps of garbage at the outskirts of the city. Somewhere in the sweltering heat bodies are wiping the light from their eyes. Somewhere in the city there are broken bones in the streets. There will always be broken lines between the cities. There will always be light and swirling concrete in the air. There will always be bodies with bright lights in their mouths. There will always be some idea of a time before. There will always be another day. There will always be a line connecting another line. Tomorrow might arrive in the next few seconds. Tomorrow blossoms in all the entangled, radiating bodies. Tomorrow is a dream. Tomorrow is an endless, burning light cutting through the earth.

# XII

Tomorrow is an endless, burning light cutting through the earth. Tomorrow is a forgotten dream. Tomorrow is a jagged line connecting the chunks of concrete floating through the air. Tomorrow blossoms in all the sweaty, entangled bodies radiating light. Tomorrow might arrive in the next second or two. There will always be a line connecting another line. There will always be another day. There will always be some idea of a time before. There will always be bodies exploding with light. There will always be light and swirling concrete in the air. There will always be broken lines between the cities. Somewhere in the city there are broken bones in the streets and soft sheets of fresh snow. Somewhere in the light there are just the traces of bodies. Some light seeps out of the heaps of garbage at the outskirts of the city. Some light disappears under the crumbling highway. Some light carries the lingering scent of roses. Some light remembers the contours of the earth. The earth disappearing into the light. Bodies disappearing into the light. Bodies within bodies within bodies in the burning light. Bodies without darkness. Bodies exploding with light in the streets and in the lakes and in the higher parts of the sea. If there are endlessly expanding lights below and above. If the bodies are drained of blood. If there is a tumbling in the air above us. If the light never lifts. If light is gushed from every body. If some other, softer place is not softer at all. If the concrete

towers are breaking apart in the light. If the bodies can just be forgotten. If slow, intermingling drifts of bodies float through the air between the swirling chunks of broken concrete and smashed glass. If flesh is peeled from the bone beneath the lights. If the light pools beneath smashed apartment blocks. If there is still a sky ninety feet up in the air. If there are still broken bodies in all this swirling concrete. If there is the promise of spring. If the highways are just light. If the bodies are just light. If the city is just light. If the earth can be forgotten. If the broken line comes together again. If the bodies disappear into the light. If the bodies are just a dream. If the city is just a point in space. If the burning clouds drift past the highways and the streets and the city. If there is the taste of light in the air. If the bodies are forgotten. If the cities are forgotten. If the forests are forgotten. If there is ever truly a moment of darkness again. If any flesh can withstand the light. If there are lines connecting the towers breaking apart in the light. If a line can be drawn between the floating chunks of cement that are lifting off the crust of the earth. If there is still a planet after all of this. If there are lines connecting the apartments to the sidewalk to the light above. If there are trees floating above the city. If the blood sprays into the air and evaporates in the burning light. If there is light radiating in the streets. If the streets break apart and begins to float up into the sky. If the light burns through the smashed earth. If there is a knife pressed at the throat. If nothing here in this broken city is forever. If the bones float up into the light. If the thousands of glittering stars shine through the earth. If the earth is swallowed up in the light. At this height, the earth can be seen breaking apart. The horizon disintegrating. There is flesh and there are waves of

light from the sky above and there are moments when they seem to intertwine and exist together as one. A pink, delicate sky. A dazzling light from some older, softer place. Cracked rooftops. Flesh breaking apart. Just above the bodies, there are clouds of hot steam. Just between the glittering stars, there is a sprawling black emptiness. Just above the clouds. Just above the expanse. Slow, intermingling drifts of light that penetrate the skin and the concrete. Light exploding from their eyes. Bodies exploding with light. Bodies clutching knives. Bodies drifting up into the sky. Burning bodies. Grey clouds. Splintered bones. Some broken planet. Some burning light cutting across the surface of the earth. Some burning light from some older, softer place. Some apartment. Some driveway. Some stretch of highway. Some overheated car. Some ditch. Some warm body. Some crooked wilderness. Some dry heat. Some foggy windows. Some soft carpets. Some mad dash between buildings. Some long stretches of asphalt. Some soft whispers. Some burning clouds in the sky. Some distant place. Some broken bodies. Sometimes the light cuts through everything. Sometimes there is no way to tell where the light begins and ends. In the sky above, there is blood spraying into the light. In the sky above the city, there is the taste of burning copper in the air. There are still bodies wrapping themselves in bandages, trying to hold in the light. In the city, there are bodies crusted over with the residue of light. There is a bright, delicate light reflected in the brown water at the edges of the streets. Somewhere above there is a light from somewhere other than here. Some stars can still be seen in the morning above the rooftops and through the windows. Somewhere above there is a soft, silvery wind that disappears between the apartment blocks

and cuts above the streets. Somewhere above there is a tumbling in the air a mile above us. If there is space for all these bodies, it is ninety feet up in the air. Smashed highways. Splintered streets. Broken chunks of concrete towers swirling through the air. A horizon. A soft orange glow. The planet breaks apart in the light. A soft, silvery wind. Paintings of rivers. Carpeted apartment floors. The residue of the city. Bodies covered in broken glass. Bodies covered in dirt. Scarred fingers. Soft cheeks. Delicate bodies. The taste of rotting fruit in the air. Little pools of light. The smashed highway. Heaps of garbage. Snow. A winter breeze. Swirling glass ninety feet in the air. Just light exploding. Burning clouds. The centre of the city. A steep set of stairs. Concrete towers. Splintered limbs. Burned-out chasms. Curled-up bodies. Cheeks wet with the residue of light. Cheeks pressed against floating chunks of concrete. Cheeks split open by broken glass. Broken concrete towers floating through the disintegrating city. A mound of flesh. A broken river. A grey cloud pulled apart by the winter wind. Splintered rocks. Swirling pieces of concrete towers. Floating trees. Stretches of highway rising into the light. Deep, narrow ravines breaking apart. Soft, bright places. Right angles. Moment after moment. Bright mounds of wet earth. Black rocks in the park. Broken bodies. Intersecting lines. Ditches radiating light. Burning clouds. A far-off city. Waves within waves within waves. Bodies intertwining. Bodies and knives smashing into each other. Burning copper. Forests breaking apart. A tumbling in the air above. A clear sheet of water within us. Glistening garbage. Bodies rising ninety feet in the air. Memories of fire. Memories of summer. Floating pieces of apartment blocks. A horizon of light. What future. What bones. What planet. What bodies. What flesh.

What light. What bitterness. Paintings of rocks. Immovable mountains. Rotting chunks of driftwood. Broken tree branches. Cold lakes. Silvery moons. Constricting air. Countless bodies. Broken cities. Blinding lights. Smashed windows. Rushing wind. Trees and shrubs. Broken rocks in the park. Concrete rooftops. Piles of bone. Glittering stars. Groups of flesh. Memories of another life. Everything breaking apart in the light. Broken fragments of buildings rising into the sky. Crust of the earth. Crumbling planet. Bodies burning in the light. Bodies intertwining within bodies. Intermingling drifts of burning clouds. Bodies disintegrating in the light. Soft, silvery wind. Bodies floating through the streets. Scattered fire. Swirling concrete in the clouds above. Heap of bones. Bodies suspended in the light. Bodies floating through the swirling debris. A chasm. A bright pool of clear light. Some other, brighter place. Blue light. Blazing bodies. Burning orange clouds. Skylights. Asphalt. Broken bodies stretching out horizontally. Low bushes. Sky dotted with countless, floating bodies. Soft, bright places. Light pressing into every soft corner. Old, forgotten bones in the black earth. Streets and chasms. Rooftops and forests. Concrete towers and rivers. Crushed rocks. Heaps of garbage. Burning clouds. Neon lights. Breathless, drunken bodies. Collapsing roadways. Radiating eyes. Glittering stars. Expanding horizon. Broken windows. Hollow sky. A river of light. Deep chasms. Stretches of highway. Streetlights and distant hills. Smashed apartments. The shores. Crumbling concrete. Burning copper. Bodies dripping with light. Garbage in the ditches. The stream overflows. A mile above us. Concrete summits. Hills and streets. Lakes and bars. Air passing from mouth to mouth.

Glass swirling in the air. The sunken hillsides. Miles of street. Edges of the river. Stretches of highway. Bodies like fire. Light colliding and breaking apart. Narrow fissures. Black chasms. Blinding lights and radiant colours. Naked bodies. Black smoke. Broken concrete slabs. Cracked beams of wood. Pulsing neon. Wind rushing. Broken windows. Low bushes. Trees in the soft, winter wind. Flesh breaking open. Apartment blocks. Piles of dead leaves. Tree branches and garbage. Old, crooked roadways. Skyscrapers and burning bodies. Bodies with knives. Crooked teeth. Crumpled fingers. Shining pieces of glass. Stretched time and sinking air. Floating bodies. A multitude of shifting whites and blues and oranges. Bodies cut apart. Trees swaying slowly. A soft, silvery wind. Drifting heavens. Blazing vapour. Impenetrable brightness. Glittering stars. Stretches of asphalt and hills. Heaps of garbage. Floating bodies. Broken branches. Concrete towers. Soft grouping of flesh. Burning clouds. A terrace on a concrete roof. A pile of trash. A beam of light. A spinning gear. A soft, bright sky. Black smoke. Shattering glass and burning metal. Bodies colliding. Ragged concrete towers. Light radiating. Broken wood and broken glass. Swirling wind. Shattering windows. Collapsed rooftops. The gully and the soft, bright places. Apartment blocks and the overflowing rivers. The shore and the moon. Burning clouds and black roots. Severed limbs. A soft, silvery wind. Mounds of earth. The valley. Bright sheets of light. Branching pathways. Streetlights and caverns. Floating bodies and lakes. Gutters and rivers. The scent of rotting fruit. A critical velocity. A pool of light. A pile of bones. Some older, softer place. Some light touching the dead ninety feet up in the air. Piles of broken bodies. Clouds between

skyscrapers. Blinding streets. Cars on the highway. Crumpled metal in the ditches. The deep, bright centre of the earth. Cars colliding. Smashed concrete. Light pouring from the mouth. Light cutting through us. Bright, delicate sky. Glassy bones. Swirling garbage. Rotting trees. Splinters of glass. Bleeding flesh. Severed limbs. The bright, misty highway. A cool wind. Old, broken bones. Piles of old garbage. The air. A cool breeze. Asphalt and garbage and cars and old, buried bones. Bones exploding with light. One second of darkness. A memory. Thousands of smashed bodies and broken bones. Purple and blue clouds in the sunset. Clouds of red and purple and orange and pink. Thousands of apartment blocks. Millions of floating bodies. The breath of the river. Mounds of old bones. Decaying trees. Intermingling voices. Warm, soft spaces. Blinding colours. The open air. Drunk bodies. Sharp knives. Lingering silence. Light within light. Bodies with broken fingers and torn ligaments. Scars on top of scars. Cities splitting open again and again. A deep hollow. Dead bodies on the road. Pools of evaporating blood. Low-hanging pink and orange and yellow clouds. Streets drifting up into the sky. Millions of colours; millions of bodies. Soft carpets. The blood as natural as water. Fractured storefronts. Smouldering chunks of cement. Burning copper wire. Great expanses of blood. Bodies and glass and towers and rivers. Glittering pools of evaporating blood. Cascading neon. Mossy hollows. Ravines and falling leaves. The open air. Deep, bright places. Forests and straits and islets and cities. An unbroken wall of light. Broken branches. Thousands of bodies floating up over the canopy. Some waters carry the dead. The smell of garbage in the air. A soft, silvery wind. Flesh burning and rooftops and glowing

windows and concrete towers and floating bodies. Spiralling light. Endless cities. Crumpled metal. Bodies in the streets. Glassy mirrors. Bright lines running in parallel. A bright, shining place. Broken glass. Collapsing concrete. Crumbling city. A deep, bright hollow. Burning clouds. The deep stillness of the night. An endless expanse of highway. A soft, delicate place at the centre of the earth. Burning light.

*Afterglow*

# XIII

Burning light. A clear sheet of water and bodies sinking to the centre of the earth. Some waters remember the endless expanse of highway. Sounds that come from tomorrow. Burning clouds hang from the trees. A deep, bright hollow. A crumbling city ripples outward in the water. A hundred passageways. Collapsing concrete. Slow, intermingling drifts of broken glass. A bright, shining place. Light and clouds and branches. Bright lines run in parallel. Silence from the deep, narrow ravine. Broken bodies in the streets; crumpled metal in the river. Endless waters. Spiralling cities. Broken shafts of light. Concrete towers falling on the mossy floor of the forest. Rooftops and moonlight and a thousand glittering stars and a street and a mouth and a river. Some waters carry the floating bodies. A soft, silvery wind. The smell of garbage glides up to the black clouds one hundred feet in the air. There is a mist that drifts over the smouldering chunks of cement. If the forest rises. If a line is drawn around the burning copper wire. If the soft curvature of the glass reflects the light from the moon. If a street is peeled from the crust of the earth. On the shore, there is the taste of garbage in the air. At this height, about a half mile from the base of the collapsed towers, there are mounds of black earth and shrubs and driftwood. There is the sound of rushing water coming from some other, softer place. There is a nakedness out here in the cascading

neon. Sometimes there are mountain ranges and an unbroken wall of light and islets and streets and pools of evaporating blood and broken branches and fractured storefronts and rivers and floating bodies and deep, bright places and mossy hollows and fragments of driftwood and bars and breath and soft carpets and ravines that seem to drift into each other. Somewhere there is light exploding within light. Some things last forever. There is a current of air. A deep hollow. A river flowing over the city. Through the numberless branches and broken tree limbs and black rocks and piles of bone and sharp knives and mounds of earth and apartment blocks just beneath the surface. Sometimes there is garbage and old cars just above us in the air. Sometimes memories grow in these waters. There are glimpses of bright, misty highways and waterfalls and a brook that feeds into the burning clouds. Another ligament. Another pathway. Another nightfall. The stars light up a trail of memories. But memory has not come yet and the wildfire spreads over all the smashed bodies in the sunset. Which bodies hang in the air? The morning approaches beyond the splinters of glass. The current flows into the dark parts of the river. The river disappears into the swirling garbage. Somewhere out there cars collide with the brush above. There is scattered light and a critical velocity. The scent of fresh fruit and a pool of light. For a few moments, the stars can be seen through the canopy. From the distant centre of the earth that is barely visible in the light from the afternoon comes a sound that echoes across the waste waters. These woods are full. The apartment blocks and the overflowing rivers and the gully and the soft, bright places. Burned bodies below the high and broken summits. Concrete towers disappearing into the water. A narrow,

deep cavern in the rock. On the broad side of the trail, there are ragged expanses of concrete and splintered floorboards and bodies and treetops and drifting vapours and broken glass and deep laughter. The windows shatter and the dead listen. The hills and the gloom and the burning metal and the bodies colliding and the ragged concrete towers and the blazing fire and the heavens and the light that cuts through the branches and the broken wood and the black smoke that drifts around us and the glimmering moonlight and the quiet uneasiness and the heaps of garbage and the impenetrable brightness and the stretches of asphalt and the trees swaying slowly and the multitude of shifting colours in the forest. Somewhere in the trees there is a spinning gear. Sometimes in the forest the skyscrapers are no great distance. Still, the air sinks around the bodies with crumpled fingers and crooked teeth. The pathway splinters into the forest. For a few moments, there is shining glass and an ocean and wind rushing a hundred feet in the air. The narrow fissures. The pulsing neon. The cracked beams of wood. The broken concrete slabs. The burned bodies. The black chasms. The crumbling concrete. The cool spring rain. The breeze along the surface of the river. The city lights. The garbage in the ditches. Thunder rumbles beyond the distant city. The ocean swells and sinks and crashes against the rooftops. The air rises and the eyes reflect the hollow sky. Every few yards, bodies appear on the surface of the earth, are filled with light and disappear. For many minutes, there are floating chunks of cement and a cool spring wind. When the sun is setting, these bodies become bright lights in the forest, but the sun is not setting and the bodies just drift between the mossy trees. On these waters, the edges touch the

shores and the dirt paths trace back to the soft, bright centre of the earth. The breath of the bodies. The glancing eyes. The throat of the highway. These forests are full. Gliding above somewhere up in the impenetrable light is the taste of garbage. Air passes from mouth to mouth. There are narrow fissures and a river that flows past the sunken, concrete rooftops and tiny bodies in the distance and smashed apartment blocks at the base of the mountain. In the water, there is the colour of blood spilled from some other body. Some other throat. Some other, brighter place. Some oceans carry heaps of garbage. Some stretches of highway are broken. Light presses into every corner. There are precipices and paintings of rocks and air sinking into the foaming waters. There is a fierceness here that floats through the swirling debris. In six hours, these bodies will intertwine with each other. Bodies suspended in the light. Bodies floating through the forest. Bodies stretching out over the acres of wilderness. Somewhere out there is a broken skylight and glimpses of tangled bodies that disappear just as suddenly as they appear. Among the bright mounds of wet earth and broken rocks and swirling concrete and right angles. The broken bodies surround themselves with memories. Within the light. Within the throat of the river. Waves within waves within waves. There is a far-off city and burning clouds and ditches radiating light. There are intersecting lines and black rocks in the park and deep, narrow ravines. There is a steep, rugged ascent. Tomorrow is a circle of roses and rocks and shrubs. Tomorrow is filled with burning light and scattered driftwood and the scent of garbage. Some hundred feet up in the air is a deep hollow. These rocks are full of cracks. Some right angles enter into narrow passageways and some right

angles break off in the clouds above us. Some hundred feet up in the air there are no bodies. Some places are brighter than others. Some things are meant to last forever. Some broken asphalt falls back to the forest floor. At this very moment, there is a tumbling. There is a tumbling in the air a mile above us that runs straight through the open heavens and into some other, brighter place. A deep hollow. There is scattered driftwood and floating chunks of cement and mossy stumps and the taste of light in the air. There is a path that winds around the river. A clear river with black rocks just below the surface. Somewhere there is a river and fragments of rocks. There is light and straight, naked rocks and immovable towers. There is a river that is ragged with rocks and floating garbage and broken branches. In the deeper parts of the river, there are crevices and fissures and earth breaking apart. There are black rocks and a deep, narrow chasm.

# Acknowledgements

Chelsea and Phoenix—without you two, this book would not be possible. My endless love and gratitude for being my first readers, my first listeners, and for always being there for me.

Stephanie, Jared, Cody, and Warren—thank you for always believing in me and for shaping these ideas alongside me.

Steve, Derek, and Greg—thank you for reading earlier versions of this book and lifting me up with your words when I needed a boost to keep going.

Thank you to the editors of *The Capilano Review*, *Ariel*, *Watch Your Head*, *Partial Zine*, *Canadian Literature*, *Malahat Review*, *Belfield Literary Review*, and *Ampersand Review* for publishing earlier excerpts from this book, especially Sophie, Deanna, Adam, Kathryn, Andrea, and Paul.

To everyone at M&S—Stephanie, Jared, Alicia, Kim, Terri, and all the other folks working hard to put books into the world—thank you for making this book a reality.

Finally, thank you to the Edmonton Arts Council, the Alberta Foundation for the Arts, and the Canada Council for the Arts for funding this project and for making the time I spent writing this book liveable.